relief.

imensions. One more

s a picture perspective:

struction: to wit, the depth

. a simple problem is chosen

by which we may make

our relief, in

law may under circumstances

ly approximate its results to

tances it may be substituted

plane

top table is placed in perspective

spective of three dimensions

awing being shown pointed out

A

DRAWING MANUAL

BY

THOMAS EAKINS

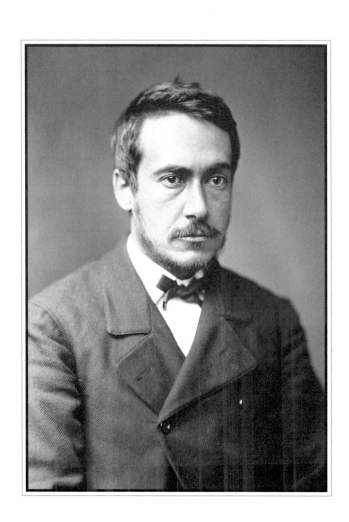

A

DRAWING MANUAL

BY

THOMAS EAKINS

Edited and with an introduction

BY

Kathleen A. Foster

and an essay

BY

Amy B. Werbel

PHILADELPHIA MUSEUM OF ART

in association with

YALE UNIVERSITY PRESS

New Haven and London

This publication was supported by an endowment for
the Center for American Art at the Philadelphia Museum of Art.

Front cover: Thomas Eakins, detail of *Drawing 1 [The Law of Perspective]* (see p. 123).

Back cover: Thomas Eakins, detail of *Drawing 5 [Viewer Position]* (see p. 123).

Endpapers: Thomas Eakins, detail of manuscript page from "Sculptured Relief." Philadelphia Museum of Art.
Gift of Mrs. Ruth Strouse in memory of her father, Joseph Katz, 1969-198-90.

Frontispiece: Frederick Gutekunst, *[Thomas Eakins at about Age 35]*, c. 1879. Gelatin print on cream wove paper,
5 x 4 inches (12.7 x 10.2 cm). The Pennsylvania Academy of the Fine Arts, Philadelphia. Charles Bregler's
Thomas Eakins Collection, Purchased with the partial support of the Pew Memorial Trust, 1985.68.2.16.

Produced by the Publishing Department
Philadelphia Museum of Art
2525 Pennsylvania Avenue
Philadelphia, PA 19130 USA
www.philamuseum.org

Published by the Philadelphia Museum of Art
in association with Yale University Press

Edited by David Updike
Production by Richard Bonk
Designed by Frank Baseman
Printed and bound in Canada by Transcontinental Litho Acme, Montreal

Library of Congress Cataloging-in-Publication Data
Eakins, Thomas, 1844–1916.
 A drawing manual / by Thomas Eakins; edited and with an introduction by Kathleen A. Foster
 and an essay by Amy B. Werbel.
 p. cm.—(Primary sources in American art; no. 1)
Includes bibliographical references.
ISBN 0-87633-176-2 (PMA hardcover)—ISBN 0-300-10847-8 (Yale hardcover)
 1. Drawing—Technique. 2. Eakins, Thomas, 1844–1916.
 I. Foster, Kathleen A. II. Werbel, Amy Beth. III. Title. IV. Series.

NC730.E23 2005
741.2—dc22 2004058508

Contents

Foreword

Thomas Eakins, Philadelphia's great realist artist and teacher, remains a powerful presence in two of the city's arts institutions: the Pennsylvania Academy of the Fine Arts and the Philadelphia Museum of Art. At the Academy, founded in 1805, Eakins studied from 1861 to 1865 and then, from 1876 to 1886, strode the studios of the glorious "new" building by Frank Furness at Broad and Cherry streets as professor and director of the schools. The Museum, chartered in 1876 out of the American Centennial Exposition (where Eakins exhibited his early master-piece *The Gross Clinic*), would ultimately come to hold the largest collection of his painting and sculpture. Over time, both institutions have become rich repositories of Eakins's art and papers: the Academy purchased paintings from the artist during his lifetime, and the Museum received majestic donations in 1929 and 1930 from his widow, Susan Macdowell Eakins, and her friend Mary Adeline Williams to form the core of a memorial collection.

Since that time, both institutions have gained important additions, including the Museum's receipt from Mrs. Ruth Strouse in 1963 of the manuscript of Eakins's drawing manual, prepared for his students at the Academy and the Art Students' League of Philadelphia but never published. To the Academy came the spectacular acquisition in 1985 of the long-hidden collection of Eakins's student Charles Bregler, including a trove of manuscripts, drawings, photographs, and sketches. Among the drawings in Bregler's hoard were the illustrations that Eakins had prepared for his drawing text. At long last, the parts were in public hands at sister institutions.

Now, as the Academy celebrates its two hundredth anniversary, the Museum is delighted to be able to celebrate the ties between us with the publication of a book that, we hope, looks something like the manual that Eakins envisioned. Together, the

text and illustrations demonstrate the scientific discipline of Eakins's method and the plain, practical, and professionally focused quality of his teaching, which made the Pennsylvania Academy the most progressive and thorough art school in the nation during his tenure. Although perspective and mechanical drawing are no longer taught in this fashion at the Academy, Eakins's curriculum reminds us that the basic principles of keen observation, preparation, and study remain evergreen as the Academy rededicates itself to the teaching of artists and launches its third century with the opening of a splendid new building for its school.

Derek Gillman, President and Edna S. Tuttleman Director of the Academy, and I are grateful to many colleagues at the Academy for their work on this collaborative project, particularly the archivist, Cheryl Leibold, who encouraged the idea as part of the anniversary celebrations. We thank her colleague Barbara Katus, who photographed the drawings for publication, and are also grateful for the support of Kim Sajet, Gale Rawson, and Robert Harman. At the Museum, the project was gladly spearheaded by Kathleen A. Foster, the Robert L. McNeil, Jr., Curator of American Art, who was curator at the Academy when the Bregler Collection was acquired. Her knowledge of the Academy's drawings and the context of Eakins's teaching has made her the ideal editor of the manuscript and author of the introduction. Amy B. Werbel, associate professor at St. Michael's College in Colchester, Vermont, who collaborated with Foster and others on the exhibition catalogue for the Museum's 2001 Eakins retrospective, has contributed an essay placing the artist's text "in perspective," in relation to earlier nineteenth-century drawing instruction manuals. The Museum's Publishing Department has entered into the spirit of this unusual book by seeking to give it an appropriate historical appearance, and we are grateful for the work of Sherry Babbitt, David Updike, Rich Bonk, and the designer, Frank Baseman. Additional help came from staff in the American Art Department, including Carol Ha, Gabriela Hernández Lepe, and Audrey Lewis.

The Museum's new Center for American Art, created in 2002, is also pleased to launch this book as the first publication in a projected series of Primary Sources in American Art, designed to bring unstudied documents and images to light. We are deeply grateful to Robert L. McNeil, Jr., for the endowment of the Center, which has supported the publication of this book as well as other programs meant to enrich our understanding of the artistic heritage of Philadelphia and the United States. We present this book to the public as a salute to the Pennsylvania Academy of the Fine Arts, together with warmest congratulations and best wishes for a spectacular anniversary year.

ANNE D'HARNONCOURT
The George D. Widener Director and Chief Executive Officer
Philadelphia Museum of Art

The Drawing Manual
of Thomas Eakins

Kathleen A. Foster

THOMAS EAKINS (1844–1916), said to be "the greatest draughtsman in America"[1] in 1882, didn't really like to draw. He rarely sketched in pencil and hurried his students into working with brush and paint. He did like teaching, but was fired twice for his insubordinate, unconventional ways. Let us consider, then, the drawing manual this man wrote for his students at the Pennsylvania Academy of the Fine Arts (PAFA) in Philadelphia between about 1881 and 1885. Interrupted by the trauma of his forced resignation from the Academy in February 1886, his manuscript was illustrated but never completed, his book never published. The parts were saved, sequestered, separated, lost, then rediscovered. Here, at last, they are reunited to illustrate the qualities of Eakins's mind and method and to teach a new generation how to see, think, and perhaps even draw in Eakins's way.

Before he came to prefer oil painting, Eakins intended to be a drawing teacher. Star drawing student at Central High School in Philadelphia, he applied for (but did not get) a position teaching drawing classes there in 1862, the year after he graduated. Son of a drawing master, he worked for his father for a time, inscribing documents and teaching penmanship. Then, taken by an ambition to become a painter, he traveled to Paris in 1866 to study at the Ecole des Beaux-Arts. After returning to Philadelphia in 1870, he began to teach soon after scoring his first successes at "picture making." In 1873, the members of the Philadelphia Sketch Club invited Eakins to direct their evening classes, organized to fill the void created by the suspension of teaching during the construction of PAFA's new building at Broad and Cherry streets. When the Academy reopened in 1876, he stepped forward to assist his old and failing professor, Christian Schuessele, first as a volunteer and eventually as a paid instructor. Chief demonstrator in the anatomy lectures of Dr. W. W.

Keen, Eakins began to supervise the drawing classes. In 1877 he proposed teaching his own course in perspective. This course was not approved, but when Schuessele died in 1879, Eakins won his former professor's position and soon took charge of the entire curriculum. By 1882, when he was named Director of the Schools, Eakins had already begun to reshape the Academy as a radicalized version of the Ecole des Beaux-Arts and the most progressive art school in the Western hemisphere.[2]

In March of 1880 Eakins commenced his first series of evening lectures on drawing. The school circular for 1882 announced that "a course of eight or more lectures on perspective and composition will be given by the Director during the months of March and April." Designed to follow Dr. Keen's fall lectures on artistic anatomy, Eakins's course was free to Academy students and three dollars to others.[3] Only the perspective lectures drew outside subscribers; "stonecutters who worked on tombstones would come," remembered Eakins's student Tommy Eagan.[4]

Like the supplementary classes at the Ecole in Paris, Eakins's lectures were given at night, so as not to waste good daylight hours needed for painting and modeling the human form. Along with lectures on art history by visiting scholars and critics, or his special demonstration of motion photography in 1885, such sessions were seen as enrichment of the main curriculum. The study of artistic anatomy and anatomical dissection, while not required, was strongly recommended, and the emphasis on such knowledge colored the entire curriculum. Likewise the lectures on perspective were not mandatory, but were encouraged as part of the scientific and professional culture of the school.[5] While some students must have dreaded or avoided these classes, the enthusiasts found them brilliant and accessible. "There are no laws on these subjects so simple as Eakins'," wrote his student Charles Bregler, who noted that he had "seen many books on these same subjects that give one a headache."[6] To the clarity of his speech, which can be imagined from the directness of his prose, Eakins added multiple visual aids: lantern slides, blackboard diagrams, and "ingeniously constructed models on a large scale."[7] His student Adam Emory Albright remembered "an elaborate mechanical construction which involved a wire screen, thread, and squares drawn on the floor" to demonstrate "a scientific method for determining accuracy of perspective."[8] As with his anatomical lectures, which used live models, an anatomical figure, casts of dissected subjects, and a skeleton that Eakins would pack with clay "muscles" and move with pulleys, the message came through clearly and indelibly. "I can still hear him say, 'Don't forget the horizon follows your eyes up or down, and all lines above go down and all lines below go up,'" wrote Albright in 1947. At the age of eighty-five, Albright could still recite Eakins's "one and only law of perspective" (illustrated in drawing 1, p. 48 below) in a nutshell: "Twice as far off, half as big."[9]

Like many successful professors then and now, Eakins contemplated the pro-
duction of a textbook to accompany his lectures, offering recapitulations of infor-
mation given in class, homework exercises, useful tips, diagrams, and suggestions
for advanced study. He told his students to buy a copy of *Gray's Anatomy* to sup-
plement the fall lectures and the dissection sessions, but he had no satisfactory text
for the perspective classes. It seems that he began to consider writing his own
drawing manual about a year after he began to lecture, as suggested by the water-
marks on his paper: the very first illustration (drawing 1) was made on fine English
paper watermarked 1881; another (drawing c[1], p. 90 below), on the subject of sculp-
tured relief—the final section of the manuscript—is on paper dated 1883.[10]

The professional and emotional upset of 1886 surely halted Eakins's work on the
book, just as it interrupted his teaching. By removing the loincloth on a male model in
a lecture given to a class with women students, Eakins defied the stated rules of the
Academy's Committee on Instruction and was asked to resign.[11] Loyal students
departed with him to form the Art Students' League of Philadelphia, where he gave
his lectures gratis for several years, and he continued to teach in New York, Brooklyn,
and Washington, generally on artistic anatomy. With this encouragement, the book
project seems to have rallied briefly, as indicated by one drawing on paper water-
marked 1887. This illustration, a variant of drawing 15 (p. 66 below), undertakes the
manual's spiral staircase exercise with a sixteen-step floor plan (instead of the twelve
called for in the text) and, unusual for these drawings, employs colored inks.[12]
Changes made in pencil (such as an *A* altered to *a*) on other illustrations indicate that
he was tinkering with them but had not yet updated the text.

Indeed, much remained to be done. The order of the sections was never clearly
established, and the drawings were never united into a single numbered series.
But Eakins felt it was finished enough to mark the illustrations with instructions
for the printer, and he evidently gave it to a friend to critique. "This does not seem
to me to be true," comments a new handwriting in graphite across the text on page
two; "it is badly stated or not in place." This blunt (and wrongheaded) criticism
must have come from a good friend, and naturally one wonders if such remarks dis-
couraged Eakins's progress.

He had other reasons to lose momentum after 1887. His student base was dwin-
dling as the Art Students' League faltered and his own lecturing decreased; in 1897,
after more scandals—including being fired again for removing a loincloth during an
anatomy lecture at the Drexel Institute of Art, Science and Industry in Philadel-
phia—he ceased teaching altogether.[13] His place at the head of Philadelphia's art
students had been assumed by his assistant, Thomas Anshutz, who took over
Eakins's position at PAFA, and by the principal of the Pennsylvania School of

Industrial Arts, Leslie W. Miller, who published *The Essentials of Perspective* in 1887, effectively capturing Eakins's market.[14] But the authors of all such books would soon suffer from the accelerating pace of change in the art world. Art instruction manuals are rarely written by avant-gardists; textbooks tend to express the wisdom of reputable, mainstream figures, who preach to a naïve congregation of students and amateurs, often for decades after their own work has fallen out of style. Eakins, in his forties, was already losing all but the most old-fashioned audience. As Amy Werbel notes in her essay (see pp. 27, 38–40 below), by 1890 realist drawing systems had given way to the taste for Barbizon "poetry" and Impressionist spontaneity, soon followed by enthusiasm for yet more subjective Post-Impressionist decorativeness and symbolism. Eakins, still advocating the naturalism of his student days in the 1860s, rapidly found himself in the rear guard, alongside Miller and every other teacher of linear perspective.

At the same time, Eakins was less engaged by the issues of perspective and reflection. His passion for camera studies in the early 1880s had inspired his use of a new method based on composite photographs, which had largely superseded drawings in his preparatory work.[15] After Eakins left the Academy, he turned primarily to indoor subjects and especially to portraiture. Typically, his life-size, half-length or smaller portraits required no perspective studies. He did continue, however, to make perspective layouts for his full-length portraits, such as the great series of clerics painted at the turn of the century or the standing image of Miller painted in 1901 (fig. 1). Charles Sheeler, future pioneer of Precisionism, was among Miller's students who surreptitiously watched Eakins prepare drawings for their teacher's portrait. Sheeler recalled that "this careful procedure led us to the conclusion that the man, whoever he was, could not be a great artist, for we had learned somewhere that great artists painted only by inspiration, a process akin to magic."[16] Eakins's naturalism and the disciplined methods that supported it held no appeal for the next generation.

So Eakins's manuscript went into a drawer, where it remained until his wife, Susan Macdowell Eakins, died in 1938, more than twenty years after the artist's death. Mrs. Eakins and her friend Mary Adeline Williams had already given the Philadelphia Museum of Art a magnificent collection of work in 1929 and 1930 to establish an Eakins memorial gallery. The intent of their gift was a grand survey of Eakins's accomplishment, not an archive or study collection, and no manuscripts or memorabilia were offered. Such auxiliary material, including letters and notebooks, numerous drawings, photographs, oil studies, sculptures, and personal possessions, remained in the Eakins house, where much of it was recovered by his student Charles Bregler after Mrs. Eakins's death.[17]

Fig. 1. Thomas Eakins, *Portrait of Professor Leslie W. Miller*, 1901. Oil on canvas, 88 x 44 inches (223.5 x 111.8 cm). Philadelphia Museum of Art. Gift in memory of Edgar Viguers Seeler by Martha Page Laughlin Seeler, 1932-13-1.

Bregler, remembering Eakins's 1885–87 lectures at the Academy and the Art Students' League, lovingly studied the manuscript and made notes from the text, hoping someday to reenact the lectures himself. In 1931, Bregler had written two articles about Eakins as a teacher, based on his own notes and recollections of Eakins's classroom sayings, bolstered by study of the manuscripts retained by Mrs. Eakins.[18] He also attempted to conserve the brittle and damaged perspective drawings. In 1944, when a major retrospective of Eakins's work was exhibited at the Philadelphia Museum of Art, Bregler sold two perspective drawings to the Museum (see fig. 4) and some of his most important paintings, drawings, and memorabilia—

including the drawing manual manuscript—to the advertising executive and collector Joseph Katz. In 1961, most of Katz's collection, including two pen-and-ink illustrations to the text (but not the manuscript itself), was purchased by Joseph Hirshhorn, who in turn gave all his Eakins material to the Hirshhorn Museum and Sculpture Garden in Washington, D.C., in 1966.[19] After Katz's death, the manuscript went to his daughter, Mrs. Ruth Strouse, who gave it to the Philadelphia Museum of Art in 1963, in her father's memory.

The manuscript's arrival at the Museum created a stir in the Conservation Department, where Theodor Siegl, the conservator of paintings, had gained an intimate knowledge of Eakins's technique from years of studying and treating his work. Siegl, who later authored a handbook of the Museum's Eakins collection, immediately began to visualize a publication of Eakins's drawing book. Sally Williams, head of the Museum's Publications Department, shared his vision and prepared a typescript from the manuscript in the 1960s, which for more than thirty years has been shared with scholars in lieu of the disjointed and sometimes illegible original.

George H. Marcus took up the project when he replaced Williams in 1968, and with Siegl he welcomed the participation of Dr. Joel Henkel, a physicist from Youngstown State University in Ohio, who indicated an interest in the manuscript as well as a willingness to supply the missing diagrams. Henkel was confident that the drawings could be reconstructed from context, and he supplied at least one sample illustration, which no longer survives. He also suggested an order to the sections in the text, proposed headings for several untitled chapters (which we have adopted in this book), and recommended the segregation or elimination of unrelated or peripheral sections (included here in the Appendices).[20]

The project foundered with Siegl's untimely death in 1976, but rose again with the emergence of the remainder of Bregler's long-lost collection, which was purchased by PAFA from his widow, Mary Picozzi Bregler, in 1985. Selectively exhibited at the Academy in 1992 and fully published in my catalogue, *Thomas Eakins Rediscovered: Charles Bregler's Thomas Eakins Collection at the Pennsylvania Academy of the Fine Arts* (Yale University Press, 1997), the newfound drawings immediately revived the scheme to publish the book. Plans were sidelined once again, however, both by the need to publish all the Eakins material in the Bregler Collection—which eventually comprised three volumes on the papers, photographs, and artwork—and by my departure for new projects at Indiana University. My return to Philadelphia in 2002 brought the Academy and the Philadelphia Museum of Art together again on this project, reuniting old friends and colleagues to regather the scattered pieces of Eakins's project.

The book that emerges from this collaboration has been sparked by the rediscovery of the drawings, which have in turn clarified the sequence of the manuscript. Most of the drawings are called out in the text, and we have placed them in this book accordingly. Eakins neatly labeled the first twenty-seven illustrations to lead the student through the sequence of linear perspective and mechanical drawing.[21] From there, three series of drawings, labeled a^1–a^7 (on reflection), b^1–b^2 (on isometric drawing), and c^1–c^6 (on sculptured relief), illustrate three additional chapters that Eakins himself had not conclusively ordered in the manuscript. In the present text, these sections have been placed in the order b, a, c simply because the section on isometric drawing seems to follow logically from Eakins's discussion of mechanical drawing. Isometric drawing is followed by the chapter on reflections, at the end of which I have also tucked his brief and probably unfinished discussion of "Shadows" (along with one unlabeled and previously unidentified drawing) and his even briefer note on "Framing the Picture," to conclude the discussion of projections on a two-dimensional surface. This places the section on sculptured relief at the end, fittingly set apart by its treatment of projection on a three-dimensional surface, as well as by Eakins's own annotation across the first page: "I believe this paper to be entirely original" (fig. 2).

For the purposes of this publication, Eakins's drawings—many of which show marked signs of aging, including stains, foxing, and torn edges—have been reproduced to create, as much as possible, the crisp black-and-white effect he would have expected in an illustrated book printed in the 1880s. Eakins's work as an illustrator for *Scribner's Monthly* introduced him to the technology of wood engraving, where the artist's black-and-white image was photographically transferred to a block of wood and then hand cut by a professional engraver in preparation for printing. In the early 1880s this technology was giving way to photomechanical processes that eliminated the participation of the engraver and ensured the exact reproduction of the artist's line. Gray tones were still difficult to achieve, however, and expert illustrators anticipated this by using crisp lines and hatching rather than washes to represent shadows. Eakins, operating between these two technological generations, produced drawings that easily could have accommodated either process. More important, he was in the business of being clear and didactic, and he employed a drawing style exactly suited to his purpose. That this blunt, abstract, black-and-white manner appears nowhere else in his work tells us much about Eakins's practical and compartmentalized method.[22]

We have used the digital processes available to today's printers to erase Eakins's pencil annotations along with the stains, smudges, and damaged edges of the paper, and to give the illustrations the sharp contrast Eakins surely expected in the final

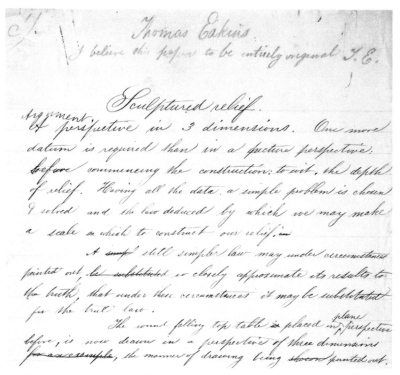

Fig. 2. Thomas Eakins, detail of manuscript page from "Sculptured Relief."
Philadelphia Museum of Art. Gift of Mrs. Ruth Strouse in memory of
her father, Joseph Katz, 1963-198-90.

product. Wherever he included them, we have followed Eakins's penciled instructions on the reduction of his drawings to a certain scale, often to 1:24 life, or exactly half as large as the assignment given (at 1:12 scale) to his students in the text. Digital technology has also allowed us to insert lines and letters missing as a result of damage or loss, and to change lettering to follow Eakins's text or pencil corrections. We have felt confident about making these alterations in the drawings, knowing that Eakins expected them to look "perfect" in his publication. Modern readers can see the unaltered appearance of these images and read their annotations in *Thomas Eakins Rediscovered* and in Phyllis Rosenzweig's thorough catalogue of the Eakins collection at the Hirshhorn Museum and Sculpture Garden.[23]

The necessary size of the reduced drawings established the size of the book, and cues from the third draft influenced the page layout and format. Eakins's instructions to use "small type" for certain paragraphs containing précis or summaries have been heeded. Other late-nineteenth-century drawing manuals, as well as var-

ious PAFA publications from the mid-1880s, inspired the typography and general design of this book, which has been expertly orchestrated by Frank Baseman. Knowing that this is not a true facsimile, because no original exists, we have nonetheless tried to suggest the taste of the 1880s and the practical, professional spirit of Eakins's teaching.

The manuscript itself has likewise been edited to make the book that Eakins might have imagined. It is impossible to know how close he felt his manuscript was to completion, and probably he would be horrified to see some of the more spontaneous sections in print. The present text is based on the "best" version of prose that sometimes exists in three drafts, sometimes only in one, at either the Museum or the Academy. In general, Bregler's division of the manuscripts in 1944 sent the more polished and legible final drafts out into the world and ultimately to the Museum, while the more informal preliminary drafts stayed in his possession and went to the Academy.[24] A few fragments from a later draft that stayed behind with Bregler have now been reintegrated and are noted in the text. A few variant or excised sentences have also been inserted in brackets or given in notes when they seemed revelatory or added to the coherence of the text. For the most part, however, I have followed Eakins's final version, understanding that his changes from one draft to the next express his will to streamline his prose and hone his examples.

Eakins's process began on common lined letter paper, in pencil scrawls with many cross-outs, insertions, sentences written sideways up the margin, and tiny drawings inserted in the text. "The science of linear perspective is one of extreme simplicity & easy comprehension," he wrote at the top of a page evidently torn from one of his sketchbooks and then folded three times before being stuffed into a pocket. The second draft was written on larger sheets of unlined paper, in ink, with pencil corrections; the third draft (see fig. 2) is on high-quality paper (also used for some of the drawings), often watermarked "Westlock," and in Eakins's most stately, public penmanship. Yet even this draft has been corrected in pencil; obviously, it was still a work in process.

Some sections of the manual, such as "Shadows" and "Notes on Framing," and two of the three tangential texts included in the Appendices, exist only in one slightly chaotic draft. These ragged sections have been more challenging to edit, since they include many false starts and cross-outs; I have pruned them in places as a copyeditor would, deleting redundant phrases and regularizing grammar and spelling. I have benefited from Sally Williams's initial transcript, and was helped again with the most puzzling sections by the Museum's fine editor, David Updike. However, I have not tried to force meaning when things get confused, but instead have chosen to retain Eakins's alternate wording in brackets.

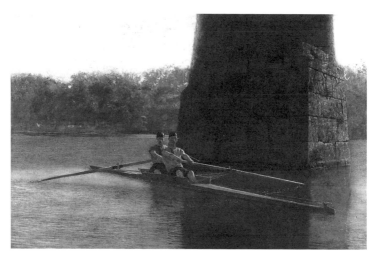

Fig. 3. Thomas Eakins, *The Pair-Oared Shell*, 1872. Oil on canvas, 24 x 36 inches
(61 x 91.4 cm). Philadelphia Museum of Art. Gift of Mrs. Thomas Eakins and
Miss Mary Adeline Williams, 1929-184-35.

Siegl characterized the papers at the Museum as "lecture manuscript and
notes," and Bregler described them as based on Eakins's lectures at the Academy,
but only one text (see Appendix II: "Notes on the Differential Action of Certain
Muscles Passing More Than One Joint") actually reads like the notes to a speech.
Most of the texts are presented as "chapters," headed by a précis and with affil-
iated drawings, and are clearly intended for publication in book form. Perhaps
Eakins read these drafts aloud to his classes, but students' accounts of his lectures
suggest that he had a more varied and informal delivery. In either case, the pres-
ent texts show a range of polish.

The first five chapters are the most detailed and complete, and the most thor-
oughly illustrated, carrying the student through the principles and methods of
three drawing systems: linear perspective, mechanical drawing, and isometric
drawing. As a realist painter, Eakins was committed to depicting the modern
world; as a scientific thinker, he was dedicated to mathematical correctness and
geometrical clarity. The center of his art was the human figure, rendered with con-
vincing weight and roundness, but to make the pictorial illusion complete, such fig-
ures needed to occupy an equally credible space. Although claims have been made
for his originality on the subject of linear perspective,[25] Eakins's system was
notable more for its simple, practical approach; as Werbel argues in her essay
below, his democratic accessibility and applicability made his text distinctively
American, and even slightly backward-looking.

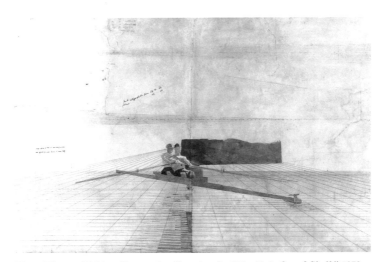

Fig. 4. Thomas Eakins, *Perspective Drawing for "The Pair-Oared Shell*," 1872. Graphite, ink, and watercolor on off-white wove paper, $31^{13}/_{16}$ x $47^9/_{16}$ inches (80.8 x 120.8 cm). Philadelphia Museum of Art. Purchased by the Thomas Skelton Harrison Fund, 1944-45-1.

Eakins's "one and only law of perspective," introduced in his first chapter, proposes a simple ratio of proportions built on the three variable coordinates of any perspective drawing: the station point of the artist or viewer, the placement of the picture plane (the canvas or paper), and the location of the objects to be depicted. All three must be fixed before plotting out the space and putting objects within it; as he warns, changes to any one will alter the scale of the figures and the recession of the space. For Eakins, the determination of this ratio became the identity of the image, its perspective fingerprint, rarely to be repeated. Seeking variation on a theme, he took pleasure in working all the changes. His own sporting pictures, such as *The Pair-Oared Shell* of 1872 (fig. 3), and large standing portraits (see fig. 1) illustrate his delight in playing with these variables. Practicing what he preached, Eakins first prepared a scaled plan, literally a map of his pictorial space. Two surviving preparatory drawings for *The Pair-Oared Shell*, both at the Philadelphia Museum of Art, give a textbook demonstration of the next step: projecting this plan into perspective. Eakins's first drawing (not illustrated) plots out the position of the shell in relation to the bridge pier; the second (fig. 4) studies the pattern of reflections on the water. In both drawings, the placement of the center line and the horizon (or eye level) is clearly visible. The intersection of these two lines, at the "vanishing point" of all lines running at right angles to the picture plane, is (as usual for Eakins) inconspicuously lost in shadow. Also apparent from these draw-

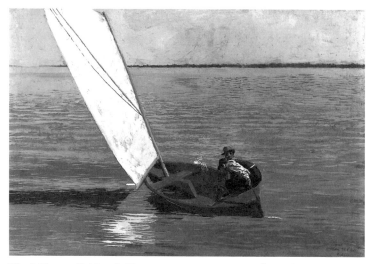

Fig. 5. Thomas Eakins, *Sailing*, c. 1875. Oil on canvas, 31⁷/₈ x 46¼ inches
(81 x 117.5 cm). Philadelphia Museum of Art. The Alex Simpson, Jr., Collection,
1928-63-6.

ings is the moderating effect of a long viewing distance (six feet), which slows the
pace of foreshortening of the rowing shell. Eakins's careful manipulation of a finite
viewer position, at a very particular time and place, organizes the two-dimensional
pattern of the composition while building a sense of the truth and immediacy of
his subject, creating a modern, subjective "impressionism" by the most contrived,
academic means.[26]

Eakins follows his chapters on linear perspective with one on mechanical draw-
ing, a system of projection that posits the viewing distance at infinity—that is, so
far away that there is no foreshortening of the figure as it moves in space: parallel
lines remain parallel, rather than converging like distant train tracks. Eakins intro-
duces the subject as a technique for engineering drawing and commercial design,
but quickly moves on to demonstrate the utility of this system for tricky pictorial
subjects, such as a yacht in open water. "A boat is the hardest thing I know of to
put into perspective," he told Bregler. "It is so much like the human figure, there
is something alive about it."[27] To analyze that aliveness, he demonstrates how the
boat form can be circumscribed by a box, which is then set in space, using princi-
ples of mechanical drawing. Breaking the process down into separate components,
he gives the "simple brick-shaped form" of the yacht three different tilts in
sequence, representing the track of the boat into space, its rise on a wave, and its
roll in the wind. To calculate foreshortening, this tilted brick could then be set into

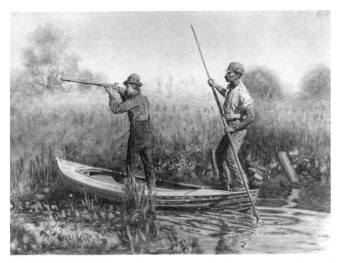

Fig. 6. Thomas Eakins, *Rail Shooting*, 1875–79. Wash on paper, $8^7/8$ x $12^3/16$ inches (22.6 x 31 cm). Yale University Art Gallery, New Haven. Mabel Brady Garvan Collection, 1948.213.

a linear perspective grid. Two of Eakins's paintings from the 1870s, probably well known to his students, amply illustrate this process: *Sailing* (fig. 5) and *Starting Out after Rail* (1874; Museum of Fine Arts, Boston), which also makes a cameo appearance in drawing 5 of the manual (p. 50 below).

Eakins returns to the problems of painters and illustrators in his section on reflections, which again draws on his scientific interest in optics and quotes from his own paintings of the previous decade. Eakins had already worked out the geometric analysis of reflections on choppy water, according to the system in his text, in his drawing for *The Pair-Oared Shell* (fig. 4); the effect in a painting appears brilliantly in *Sailing* (fig. 5). In his diagram (drawing a[4], p. 83 below) for the drawing manual, he uses a much simpler example that shows a post reflected in the marshes, also seen in *Rail Shooting* (fig. 6), a painting that also demonstrates the "caustics" reflected from the water onto the side of the skiff.

In the final chapter Eakins turns, with some pride (see fig. 2), to sculpture. His interest in this subject came from a profound respect for the tradition of bas relief, represented in "highest perfection" by "the frieze of the Parthenon by Phidias," and perpetuated by the sculpture program he had known at the Ecole des Beaux-Arts. To Eakins, bas relief was the most challenging kind of sculpture, and he was proud that he had conquered its difficulties. "If you make the least error in a relief it won't look right," he told Bregler. "There are very few who understand the law

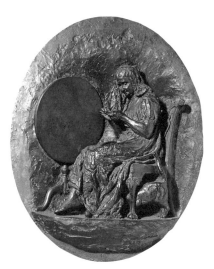

Fig. 7. Thomas Eakins, *Knitting*, 1882–83 (cast 1930). Bronze, 22¼ x 31
x 3 inches (56.5 x 78.7 x 7.6 cm). Philadelphia Museum of Art. Gift of
Mrs. Thomas Eakins and Miss Mary Adeline Williams, 1930-32-22.

that governs bas relief, even good sculptors."[28] With its initial drawing on paper
watermarked 1883, this section follows the completion of his own bas relief work
for the *Knitting* and *Spinning* panels (fig. 7), finished the same year. The tilt-top
table used in several of the exercises in the manual also appears in *Knitting*, but in
the upright position; in the exercises, he proposes the much more difficult fore-
shortening of the tabletop set horizontally.

Following this final section we have appended three texts that are only tangen-
tially related to Eakins's drawing manual but seem germane to his teaching, since
they indicate his personal research interests, which centered on anatomy and optics.
Because of their diverse character, each of these sections has been introduced by a
separate editorial commentary. "Notes on the Construction of a Camera" arises from
his work on motion photography at the University of Pennsylvania, alongside
Eadweard Muybridge, in 1884 and 1885. The second appendix documents research
begun at the time of the Muybridge project, when Eakins also photographed his
assistants with pieces of a horse skeleton (see fig. 21). His research on equine anat-
omy was presented before the Academy of Natural Sciences in Philadelphia on May
1, 1894, and then published in the Academy's *Proceedings* as "On the Differential
Action of Certain Muscles Passing More Than One Joint." The notes found with his
other manuscripts on drawing follow the basic argument of his published paper, with
some colloquial variations that suggest his actual lecture presentation. The third
appendix, "Refraction," connects his skill at depicting reflections with his interest in

cameras. This long mathematical argument, which exists only in a very clean, almost uncorrected copy, has simply been summarized; Eakins intentions for this paper remain unknown, although it surely demonstrates his pleasure in the carefully built, artful proof, akin to the solution of a complex problem in painting. "You ought to take up the study of higher mathematics," he told Bregler, "it is so much like painting."[29]

Other manuscripts by Eakins remain to be published. The Museum's collection includes, in addition to the complete text of "Refraction," earlier versions or extended variants of the present texts. The Academy's collection includes additional drafts of perspective exercises that appear to be extra assignments for his classes, sections that he intended to develop, or exercises he deleted as redundant. Several drawings of geometric forms, unrelated to the style and technique of the illustrations to his manual, remain to be identified.[30]

The unpublished items simply reinforce the personality and teaching philosophy revealed in the texts and drawings printed here. Eakins's voice as a teacher emerges in both word and line: plain, direct, practical, driven by a wish for scientific precision, reliable methods, and correct results. Overall, his manual teaches the utility of drawing, rather than its pleasure. Although it was an indispensable part of his process of making art, drawing was not an end in itself for Eakins. Always impatient to get on to the more sensuous mediums of paint or clay, he made relatively few drawings, and most of them are businesslike, not beautiful. In his illustrations as well as his own perspective plans, drawing serves as a tool for planning or instructing; like mathematics and writing, it makes thinking visible.

Eakins's drawing book, then, as Sheeler might have suspected, is more about "careful procedure" than "magic." This may seem a dull message, perhaps, but it is profound in its recognition of the role of the book and the school in the education of an artist. Eakins understood that the Academy simply made available certain expensive resources—airy studios, nude models, dissection labs, camera equipment, a library—for the use of students who were fundamentally expected to develop on their own. In this environment, a professor could do no more than offer critiques, share his craft—such as the facts of anatomy or the laws of linear perspective—and set an example. Eakins's drawing manual, in this spirit, offers a plain tool to be worked for artistic ends. It does not teach "art," which students must learn from the world, from dreams and memories, from other art. Eakins knew that inspiration did not come from a drawing book. He believed, however, that anyone, with thought and effort, could command the tools of art, especially linear perspective, which is, after all, "of extreme simplicity & easy comprehension."

NOTES

[1] William J. Clark, "The Fine Arts," *Philadelphia Evening Telegraph*, November 1, 1882, p. 4.

[2] The story of Eakins's training and early career has been told often, first by Lloyd Goodrich in *Thomas Eakins: His Life and Work* (New York: Whitney Museum of American Art, 1933), and at greater length in Goodrich's revised text, *Thomas Eakins*, 2 vols. (Cambridge: Harvard University Press for the National Gallery of Art, 1982), still the most comprehensive biography of the artist. More recently, his life has been studied in Darrel Sewell, ed., *Thomas Eakins* (Philadelphia: Philadelphia Museum of Art, 2001). PAFA was notable for its emphasis on life study, and it was unique in the period in admitting women to all parts of the curriculum. Eakins's regime, which emphasized painting and clay modeling over the traditional practice of drawing from casts, was also unusual in its insistence on anatomical studies. The story of his reform of the Academy has been examined often; see Goodrich, *Thomas Eakins*, vol. 1, pp. 167–89, 279–309; and Kathleen A. Foster, "Eakins and the Academy," in Sewell, ed., *Thomas Eakins*, pp. 95–106. Also useful is Louise Lippincott, "Thomas Eakins and the Academy," in *In This Academy: The Pennsylvania Academy of the Fine Arts, 1805–1976* (Philadelphia: Pennsylvania Academy of the Fine Arts, 1976), pp. 152–87; and Elizabeth Johns, "Thomas Eakins and Pure Art Education," *Archives of American Art Journal* 23, no. 3 (1983), pp. 2–5. Maria Chamberlin-Hellmann's comprehensive "Thomas Eakins as a Teacher" (Ph.D. diss., Columbia University, 1981) also contains appendices listing his students. Eakins's ideology as a teacher, as expressed in surviving drawings and sculptures, is analyzed in Kathleen A. Foster, *Thomas Eakins Rediscovered: Charles Bregler's Thomas Eakins Collection at the Pennsylvania Academy of the Fine Arts* (New Haven: Yale University Press, 1997), pp. 225–31.

[3] Pennsylvania Academy of the Fine Arts, *Circular of the Committee on Instruction, 1882–1883* (Philadelphia: Collins, 1882), p. 10. No notes or period commentary on the lectures on "composition" survive, and it is not clear whether the present texts include material that was deemed pertinent to this topic.

[4] Margaret McHenry, *Thomas Eakins, Who Painted* (Oreland, Pa.: privately printed, 1946), p. 69.

[5] For an interview with Eakins that gives a good sense of contemporary amazement over his curriculum, see William C. Brownell, "The Art Schools of Philadelphia," *Scribner's Monthly* 18, no. 5 (September 1879), pp. 737–50.

[6] Charles Bregler to Lloyd Goodrich, January 12, 1932; Lloyd Goodrich and Edith Havens Goodrich Archive, Philadelphia Museum of Art.

[7] Pennsylvania Academy of the Fine Arts, *Circular of the Committee on Instruction, 1883–84, with Report on the Season of 1882–1883* (Philadelphia: Globe, 1883), p. 13. A handful of glass lantern slides survived in Bregler's collection and are now at PAFA, although none seem to be related to his perspective course.

[8] Adam Emory Albright, as told to Evelyn Marie Stuart, "Memories of Thomas Eakins," *Harper's Bazaar*, no. 2828 (August 1947), p. 184.

[9] Ibid. Poking fun at this mantra, Eakins's student and principal assistant Thomas Anshutz, in a spring 1884 letter to fellow student J. Laurie Wallace, noted the "slow and stately tread" of the school year at PAFA, where "perspective is now the all-engrossing topic—twice as far off, twice as far away." Quoted in David Sellin, "Eakins, the Academy, and the Macdowells," in *Thomas Eakins, Susan Macdowell Eakins, Elizabeth Macdowell Eakins* (Roanoke, Va.: Progress Press for the North Cross School Living Gallery, 1977), p. 52. On Eakins's anatomical lecturing, see Goodrich, *Thomas Eakins*, vol. 1, pp. 188–89.

[10] See Phyllis D. Rosenzweig, *The Thomas Eakins Collection of the Hirshhorn Museum and Sculpture Garden* (Washington, D.C.: Smithsonian Institution Press, 1977), p. 117, cat. 57, a variant of drawing c[1].

[11] The scandal of his departure from the Academy is told in Goodrich, *Thomas Eakins*, vol. 2, pp. 282–309; and, with new documentary context, in Kathleen A. Foster and Cheryl Leibold, *Writing about Eakins: Manuscripts in Charles Bregler's Thomas Eakins Collection* (Philadelphia: University of Pennsylvania Press, 1989), pp. 69–90. Invited to lecture on both anatomy and perspective at the Art Students' League of New York in the winter of 1885–86, Eakins completed his full course of lectures there in the spring of 1886. He returned to lecture on anatomy annually through the 1888–89 school year, but did not repeat his perspective lectures.

[12] See Foster, *Thomas Eakins Rediscovered*, p. 341, cat. 112. The differences between the drawing and the text in this exercise suggest that Eakins may have reconsidered the terms but had not yet amended his prose; possible, but less likely, is that the 1887 version was done first and the other drawing 15 made later, in conjunction with the present text. Because Eakins was expecting his illustrations to be printed in black and white, he used dashed and dotted lines rather than colored inks to distinguish different types of lines in most of these drawings.

[13] See Foster and Leibold, *Writing about Eakins*, pp. 93–95.

[14] Leslie W. Miller, *The Essentials of Perspective* (New York: Scribner's, 1887). Miller's delicate, anecdotal drawings for his book make a striking contrast to Eakins's blunt style. On Eakins's portrait of Miller, as well as the competitive relationship between the two men, see Kathleen A. Foster, "Portraits of Teachers and Thinkers," in Sewell, ed., *Thomas Eakins*, pp. 314–15.

[15] On the new method developed with photographs and its impact on his drawing, see Foster, *Thomas Eakins Rediscovered*, pp. 163–77; and Mark Tucker and Nica Gutman, "Photographs and the Making of Paintings," in Sewell, ed., *Thomas Eakins*, pp. 225–38.

[16] Constance Rourke, *Charles Sheeler: Artist in the American Tradition* (New York: Harcourt Brace, 1938), p. 15, quoted in Theodor Siegl, *The Thomas Eakins Collection* (Philadelphia: Philadelphia Museum of Art, 1978), pp. 155–56. On these late perspective drawings, see Foster, *Thomas Eakins Rediscovered*, pp. 203–24.

[17] On the Philadelphia Museum of Art's collection, see Siegl, *The Thomas Eakins Collection*. On the story of the Bregler collection, see Foster and Leibold, *Writing about Eakins*, pp. 1–22; and Foster, *Thomas Eakins Rediscovered*, pp. 1–3.

[18] See Charles Bregler, "Thomas Eakins as a Teacher," *The Arts* 17, no. 6 (March 1931), pp. 379–86; and 18, no. 1 (October 1931), pp. 29–42. In Bregler's collection, along with the illustrations for the

text, were his own notes on Eakins's teaching, taken either from the original lectures or copied from his manuscript. In 1942 Bregler told Goodrich that he had made a "complete copy" of the text at a time when he was planning to give Eakins's lectures himself, and that Mrs. Eakins then gave him the manuscript and the illustrations; see Foster and Leibold, *Writing about Eakins*, p. 187; and Bregler to Goodrich, April 30, 1942, Goodrich Archive, Philadelphia Museum of Art.

[19] See Rosenzweig, *Hirshhorn*, pp. 116–17. One drawing (cat. 56) was his final image for drawing 13; the other (cat. 57) was a variant of drawing c[1].

[20] See the correspondence from Henkel (1931–2002) to Marcus, 1974; Eakins Archive, Philadelphia Museum of Art. Siegl wrote to Mrs. Bregler in 1971, hoping for news of the illustrations, but he received no response.

[21] This first series of drawings is labeled in the same brownish ink, different from the black ink on the drawings and overriding earlier pencil numbering. This suggests a single moment when all of these drawings were ordered and numbered; see Foster, *Thomas Eakins Rediscovered*, p. 331. The later *a*, *b*, and *c* series drawings are annotated only in graphite.

[22] On the style of these drawings in relation to Eakins's other modes of drawing, see "Drawing: Thinking Made Visible," in Foster, *Thomas Eakins Rediscovered*, pp. 51–56.

[23] Foster, *Thomas Eakins Rediscovered*, pp. 331–52, cats. 92–140; Rosenzweig, *Hirshhorn*, pp. 116–17, cats. 56–57.

[24] The Academy's manuscripts are itemized in Foster and Leibold, *Writing about Eakins*, which includes a key to the set of microfiche cards that accompanies this publication; see p. 184 and microfiche series I 8/C/3-8/D/7.

[25] Siegl, *The Thomas Eakins Collection*, p. 109, citing the claims of Margaret McHenry.

[26] Ibid., pp. 54–56, cats. 9, 10. On the meaning of these two drawings, see Kathleen A. Foster, "Perspective Drawing for *The Pair-Oared Shell*," in *Thomas Eakins and the Heart of American Life*, ed. John Wilmerding (London: National Portrait Gallery, 1993), pp. 68–70. The terms of Eakins's system of linear perspective are explained and the variation-on-a-theme quality of the rowing subjects is discussed in Foster, *Thomas Eakins Rediscovered*, pp. 59–71, 123–30.

[27] Bregler, "Thomas Eakins as a Teacher," p. 383.

[28] Ibid., p. 386. "Those things by Phidias, with very little imagination you feel that they stand out full, —yet when you get around to the side you see that they are very flat." On Eakins's experience with relief sculpture, see Foster, *Thomas Eakins Rediscovered*, pp. 98–105.

[29] Bregler, "Thomas Eakins as a Teacher," p. 384.

[30] The drawings are reproduced in Foster, *Thomas Eakins Rediscovered*, p. 352, cats. 141–44; all the manuscripts at the Academy have been reproduced in the microfiche cards published in tandem with Foster and Leibold, *Writing about Eakins*. The original manuscripts are available for study at both institutions.

Last of the Art Crusaders

Amy B. Werbel

A LTHOUGH INSTRUCTIONAL art books have been widely used since Leon Battista Alberti first published *De Pictura* in 1435, their popularity has waxed and waned over the centuries.[1] One of the periods in which such manuals flourished was in the United States in the nineteenth century, during the era Peter Marzio has dubbed the "art crusade." Influenced by the widespread belief that drawing instruction could raise the cultural and economic prospects of the nation, Americans bought more than 145,000 copies of drawing manuals between 1820 and 1860. Many, such as Rembrandt Peale's ubiquitous *Graphics*, were intended for public grade school students; others were authored for the legions of Americans who took up drawing as an edifying hobby.[2] Unlike Alberti's text, these treatises emphasized drawing rather than painting, and most of them discussed mathematical systems of linear perspective only as a small part of a more universal introduction to art.

By the early 1880s, however, when Thomas Eakins, then director of the Pennsylvania Academy of the Fine Arts in Philadelphia, sat down to draft a drawing manual for his students, the enormous wave of interest that had inspired these manuals and defined the period of the "art crusade" had already crested, and the popularity of perspective drawing had largely given way to interest in more sensual approaches to rendering pictorial space. Those who have studied Eakins will not be surprised that he undertook authorship of a text that ran so dramatically contrary to the trends of his time, but a more searching analysis of the methods and topics included in his drawing manual, as well as its relationship to other similar texts, reveals much about the artist's influences and beliefs. Eakins first formed his conception of the nature and purposes of art during the art crusade; as a result, mathematics and drawing remained the ground line of his artistic prac-

tice throughout his life. His text thus owes its very existence to the works produced by earlier "art crusaders," and their spirit infuses both its practical and its philosophical pedagogy.

Two of the most obvious sources for Eakins's drawing manual are Peale's *Graphics*, first published in 1834 and studied by Eakins during his years at Central High School in Philadelphia, and the best-selling *American Drawing-Book* by John Gadsby Chapman, first published in 1847. Both Peale and Chapman can be counted among the most vociferous of the nation's art crusaders. Chapman wrote in his drawing book that art

> gives strength to the arm of the mechanic, and taste and skill to the producer, not only of the embellishments, but actual necessities of life. From the anvil of the smith and the workbench of the joiner, to the manufacturer of the most costly productions of ornamental art, it is ever at hand with its powerful aid, in strengthening invention and execution, and qualifying the mind and hand to design and produce whatever the wants or the tastes of society may require.[3]

Peale too was an outspoken advocate of such utilitarian arguments for artistic study. He stressed the efficacy of drawing instruction in teaching writing, geography, accurate proportion, and basic arithmetic. Assertions such as these reflected the philosophy with which Peale imbued the art curriculum that he designed for Central High School, where he served as drawing professor, and where Eakins acquired his first systematic artistic training between 1857 and 1861.

Central High School was the first public high school in Pennsylvania, one of only a small handful of institutions in the nation dedicated to providing higher education for gifted students who lacked the funds necessary to attend private colleges. Because Central was funded through taxpayer dollars, the curriculum had a strong slant toward utilitarian studies. The philosophy of the art crusade dovetailed perfectly with this overarching republican agenda and set the stage for the development of a drawing curriculum attuned to civic goals. As a Central student, Eakins began his formal artistic training with penmanship and drawing, taught by Peale as twin disciplines, and then moved on to more "applicative" subjects: perspective, isometric, and mechanical drawing. Eakins's own drawing manual mirrors the last two years of this curriculum fairly well: his text moves from linear perspective to isometric and mechanical drawing and also includes optics, another subject of study at Central in the years Eakins was there.[4]

Although Peale was an obvious influence on Eakins through the utilitarian art curriculum Peale implemented at Central High School, *Graphics* actually bears little resemblance to Eakins's own curriculum and the drawing manual he wrote to accompany his classes at the Pennsylvania Academy. In large part, the variances between

these educators stem from their very different audiences: Peale wrote for public school students, Eakins for more mature professional art students. Peale, for instance, devoted only two pages to actually teaching perspective, while Eakins used several dozen pages to cover the topic. Rather than relate formulae and explain the Renaissance algebra of the foreshortened grid, Peale showed students the much more popular shop method of judging distances by observing the "situation by similarity of angles" in a given scene:

> It must be now clearly established, that any three points on paper, or in a natural view, by supposing them to be the points of triangles, may be imitated by making three similar points, necessarily producing a similarity of position in those points; being the tops, bottoms, centers, or corners of objects. From any two of these points already ascertained, another may be selected for some other object, and so on to the greatest number of parts.[5]

It would be extremely difficult, if not impossible, to use this definition and the two slim diagrams on perspective that follow (figs. 8, 9) to construct a scene including objects within a foreshortened space. Rather than explore any practical or theoretical concepts of perspective, Peale swiftly moved on to sections covering geography and mapmaking, advising that "[o]ther rules of perspective may be learned from the Treatises."[6]

The "Treatises" to which Peale referred undoubtedly included several that he listed in Central High School reports to the Philadelphia Board of Controllers, among them texts by George Childs, James D. Harding, Samuel Prout, and John Varley.[7] These authors, while certainly more ambitious than Peale, were no more systematic in their approach to perspective, and again their texts bear little resemblance to Eakins's. Harding's *Lessons on Art*, for example, completely avoids discussion of perspective or even of pictorial space in general, instead providing rules for drawing types of things, such as foliage, and instruction in using various materials.[8]

A much more useful treatise at hand for Eakins would have been the second textbook assigned in Central's drawing program: A. Cornu's *A Course of Linear Drawing, Applied to the Drawing of Machinery*, translated into English by the Philadelphia educator Alexander Dallas Bache.[9] Cornu, a French civil engineer, taught students a mathematical system that provided them with rudimentary skills as mechanical draftsmen; the addition of his text to the Central curriculum reflected the school's ongoing efforts to provide useful citizens for "our age and nation."[10]

Unlike Peale, who taught his students to eyeball proportional divisions of lines by practicing free-form halving and quartering, Cornu emphasized measurement as the chief tool of the draftsman and provided the following systematic instruction in applying the measurement of objects to representation:

Fig. 8. Rembrandt Peale (American, 1778–1860), illustration from
Graphics (New York: J. P. Peaslee, 1835), p. 82. Although Peale
demonstrated the connection between ground plan and elevation in
this plate, his text was intended only to introduce the concept.

> In order to make a drawing of an object, of one-fourth its real size, assume one paper
> for the length of the foot, the fourth of its length, or $\frac{12}{4} = 3$ inches, and on this new
> length make subdivisions corresponding with those of the foot. . . . Thus, to reduce
> an object to the $\frac{1}{4}$ th, $\frac{1}{5}$ th, $\frac{1}{6}$ th, $\frac{1}{10}$ th, &c., it is sufficient to divide the principal mea-
> sure (the foot) by the numbers by which the reduction is to be made, 4, 5, 6, 10, & c.,
> and then to subdivide the quotient into parts corresponding to those of the foot.[11]

Cornu's methods are much more clearly echoed in Eakins's text than any of the
advice proffered in the drawing manuals by Peale, Harding, or Varley. Like Cornu,
Eakins recommended that students precisely measure the objects they wished to
depict and then calculate their relative measurements in the perspective scheme.
Eakins's efforts at accuracy are, in fact, even more extreme than Cornu's:

> To measure small parts of an inch you should have a diagonal scale, or make one
> on paper by dividing an inch in 10 equal parts, drawing lines at right angles
> through these divisions & marking off 10 divisions on these last lines. Diagonals
> then drawn from the tenths on the top line to the next tenths on the last line will
> in traversing the whole distance gain the 1 tenth by regular stages of tenths of
> tenths or hundredths. You can thus accurately measure hundredths of an inch
> with your compasses, and estimating between the tenths across the scale you can
> estimate very closely to the thousandths of an inch.
>
> I have drawn such a scale (drawing 16) and marked by two little circles have
> enclosed a distance of 2 inches, 8 tenths, 7 hundredths, & 5 thousandths, 2.875
> inches. *[p. 67 below]*

Although Eakins's emphasis on measurement clearly was influenced by Cornu's
earlier example, the two authors again sought to address quite different audiences.

Fig. 9. Rembrandt Peale, illustration from *Graphics*, p. 83. Again, Peale merely suggested the principles of perspective, rather than attempting to teach students how to use them.

Cornu's stated (and somewhat narrow) purpose was to train students to draw objects that might then be manufactured. Measuring skills were absolutely essential to this endeavor. A screw thread merely "eyeballed" for accuracy, even with Peale's or Varley's well-trained eye, would hardly have been likely to fit its intended mortise.[12] Eakins's insistence on correct measurement in his treatise, although informed by the larger context of the industrial revolution, aimed toward the creation of more convincing pictorial illusions.

The Central High School curriculum was a seminal influence on Eakins's drawing manual, but it was not the only educational model that informed his text. After graduating from Central in 1861, Eakins underwent a few years of rather haphazard training at the Pennsylvania Academy of the Fine Arts (he would become the first instructor to professionalize art education there a decade later) before embarking for Paris in 1866 to study with Jean-Léon Gérôme at the Ecole des Beaux-Arts. An ambitious American art student simply could not aim higher, and in fact, Eakins was the first American admitted to the master's atelier.[13]

In Paris, as in the United States in the second half of the nineteenth century, aesthetic tastes were increasingly turning away from calculated art. Many French artists (undoubtedly with relief) responded to these stylistic changes by abandoning mathematical perspective, a subject that was long considered by most as a necessary but odious aspect of their training. French art students could credit their particular difficulties trying to learn perspective in the nineteenth-century to an unlikely villain—Gaspard Monge, the greatest French mathematician of the Revolutionary era.

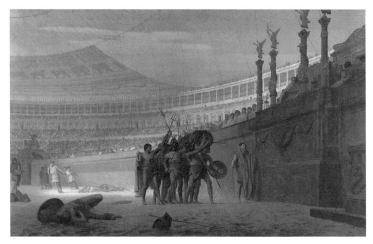

Fig. 10. Jean-Léon Gérôme (French, 1824–1904), *Hail Caesar! We Who Are about to Die Salute You*, 1859. Oil on canvas, 36⅝ x 54¼ inches (93 x 137.8 cm). Yale University Art Gallery, New Haven. Gift of Ruxton Love, Jr., B.A., 1925.

Among other things, Monge was famous for inventing a drawing system, based on descriptive geometry, that implied an infinitely extended viewpoint. Adaptations of this system for artists proliferated in the first half of the nineteenth century and are credited with forming the basis for the Neoclassical organization of pictorial space.[14]

The chief advantages of descriptive geometry over earlier perspective systems were its more precise approach to drawing forms at oblique angles to the picture plane and its ability to foreshorten curved forms. Gérôme's painting *Hail Caesar! We Who Are about to Die Salute You* of 1859 (fig. 10) is a perfect example of the type of subject Monge's system made possible and plausible.[15] Here, the curved amphitheater sweeps from the far distance into the foreground in a continuous line. The space between forward and middle ground is marked by figures, both standing and strewn on the ground in a variety of foreshortened poses. The long, curving arcs in the painting would make accurate construction very difficult using a distance-point system because there are no rectilinear planes here that might be drawn out to vanishing points along the horizon line.

By the time Eakins arrived in Paris, a new wave of treatises based on descriptive geometry was on the market. J.-A. Adhémar's *Traité de perspective à l'usage des artistes* of 1836 set the tone for those that followed; his text includes descriptive geometry but also notes that it is too difficult for artists to use.[16] While architects and engineers required the "reproduction parfaitement exacte" (completely exact reproduction) that descriptive geometry could supply, artists could use the conceptually

simpler but more cumbersome and less accurate distance-point method for the greater goal of "liberté dans le processus de la création artistique" (freedom in the process of artistic creation).[17]

While one might expect the Ecole des Beaux-Arts to have staunchly advocated the most accurate perspective studies, in fact, the up-to-date text recommended for purchase by Ecole students—David Sutter's *Nouvelle théorie simplifiée de la perspective . . . Approuvée par l'Académie Impériale des Beaux-Arts* (1859)—also downplayed the importance of mathematics. Whereas Pierre-Henri Valenciennes had started his perspective treatise at the beginning of the century with the bold proclamation that "the science of perspective is so very indispensable to the art of drawing, that painters, sculptors, and architects throughout time have had to work with great application in order to completely master it,"[18] Sutter's text begins with the much weaker observation that "the science of perspective, essentially linked to optics, is one of the most apt applications of geometry."[19] The contrast between these statements clearly demonstrates perspective's diminishing status over the course of the nineteenth century. Sutter proceeded to offer a well-organized recitation of Monge's methods, but he already had admitted that although this was an attractive theory it could not be considered "indispensable."

Despite the greater accuracy and flexibility of descriptive geometry, its inclusion in French treatises did not result in a stronger emphasis on perspective in art education generally. Gérôme himself used architects and professional "perspectivalists" to plot the space in his pictures, and even the French Neoclassical painter Jacques-Louis David, devoted as he was to the cause of revolutionary mathematics, "was obliged to have recourse to an outside hand . . . when he needed a 'purely scientific' perspective setting."[20]

It was not the conceptual difficulties of Monge's mathematics alone that sounded the death knell of perspective in France in the nineteenth century. Marianne Marcussen notes that while in the early nineteenth century viewers recognized perspectivally accurate scenes as "correct" representations of vision, by the late nineteenth century this attitude had reversed itself: "A new way of seeing—visual perception—was being elaborated, and visual perception was simply not geometric."[21] One might add to the tolling of the death knell the growing suspicion on the part of French optical theorists that light and color were at least as important as line in constructing spatial representation.[22]

Although as a student in Paris Eakins must have been aware of Monge's descriptive geometry, as well as the decreasing attraction of this and other perspective systems for artists in general, neither the new methods nor the mixed messages he may have received about them seem to have followed him home. In his drawing manual,

Eakins discussed the difficulty of transferring curved lines, but in contrast to Monge he recommended that students box curved forms rather than projecting them:

> But if this drawing of the curve should then be not fine enough, we could easily divide the sides of the square into 16, 32, 64 or as many parts as could easily give the required accuracy: and you need not imagine there need be any want of accuracy in this method of copying by eye from one set of little squares to the other set, the perspective set; for no matter if the eye itself should be so inaccurate that it would put a point in a little square as far as possible from its true place; yet by increasing the number of little squares, and so diminishing their size, a possible error can be made less than any given amount. *[p. 64 below]*

Eakins, though clearly concerned with the goal of overcoming perceived inaccuracies in the judgment of the eye, was not concerned enough to recommend the most complicated perspective system available.

Generations of scholars have positioned Eakins as the most scientific of realists in his day. Given his extensive study of anatomy and perspective, one might expect that the artist would have advocated the use of the highly accurate, elite French perspective systems based on descriptive geometry. Instead, when it came time to write his own drawing manifesto, Eakins chose as his model the book celebrated as the most beautiful and comprehensive of art crusade drawing manuals: John Gadsby Chapman's *American Drawing-Book*. Here, there was no waffling on the value of perspective, which Chapman introduced as "a Science and as an Art: as a science, in the investigation of the principles upon which is based its theory—as an art, in the mechanical or mathematical operations, by which we reach the truthful representation of any object or objects we desire, in any position or at any distance from the observer or from one another, at which such may be visible to the eye."[23] By choosing Chapman as his perspectival mentor, rather than any of the less methodical American or more complex French examples with which he was familiar, Eakins decidedly aligned himself with the art crusade philosophy that had informed his years of training in Philadelphia.[24]

The populist and democratic tenor of earlier American texts is evident from the first paragraph of Eakins's text, in which he asserts that "the science of perspective . . . is of great simplicity and of easy comprehension." On the title page of his manual, Peale had earlier exhorted students to "TRY" and promised that "[n]othing is denied to well-directed Industry." Chapman similarly guaranteed that "any one who can learn to write, can learn to draw."[25]

Eakins not only promised "easy comprehension," he also strove to describe his subject with the clear language used by art crusaders. For example, he introduced the subject of linear perspective with descriptive simplicity:

> If one should sit down in a room in front of a glass window, he could if he looked out of one eye only and kept his head still, trace upon the window glass a correct perspective drawing of the opposite houses or other objects outside, by making all the lines of his drawing exactly coincide with the real lines outside: in other words, by making each point of the drawing on the glass part of a straight line drawn from the corresponding point of the real object to the pupil of the eye. *[p. 47 below]*

A generation earlier, Chapman had heartily recommended similarly simplified introductions to perspective:

> [O]ur highest aim is to make plain and simple the first steps of knowledge to the unlearned; and, reverting to our own experience, we are not ashamed to confess how long, tedious, and dark, were the labors of our beginning, through volumes of abstruse diagrams and mathematical operations, for want of clearer light and more practical exemplification at the outset.[26]

As Chapman indicates, authors of more specialized perspective treatises began their texts with lengthy discussions of theoretical optics or the history of perspective, followed by definitions of terms. Both Eakins and Chapman avoided such "abstruse" arguments in their introductions in favor of explanations that more easily could be understood by the general public.

Despite their similarly accessible introductions, however, Chapman proceeded to a much more catholic discussion of perspectival methods than did Eakins—his aim, and his accomplishment, lay in drafting the most encyclopedic drawing book of the time. In doing so, Chapman described three perspective systems in full. First, he outlined the principles of drawing based on descriptive geometry, which we have already discussed as a limited influence on Eakins's practice. Chapman's second system of perspective is based on a gridded, measured plan (fig. 11) that resembles Eakins's own conception of the pictorial field.[27] In this second system, Chapman advocated a series of procedures identical to the later evolution of Eakins's art from compositional studies to foreshortened grids, and finally to finished paintings.[28]

> Having previously fortified himself with a general idea or impression of his subject, and perhaps with a memorandum or sketch before him, he has arranged the dimensions and general outline of the apartment, and marked off the various measurements and divisions which he will most likely have occasion to require. . . . As yet he has nothing but the tesselated floor and blank walls defined. The floor in its squares gives him as certain and well-defined a basis upon which to place the figures and objects he may desire to introduce in his picture, as to place the men upon a chess-board.[29]

Chapman's description of composition as akin to placing "men upon a chess-board" (fig. 12) is eerily manifested in Eakins's construction of *The Chess Players* of 1876 (figs. 13, 14). Another illustration in Chapman's text demonstrating the use of ground

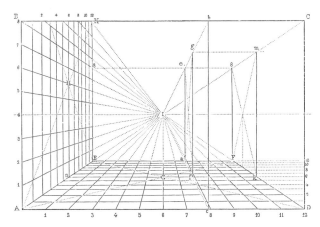

Fig. 11. J. G. Chapman (American, 1808–1889), illustration from
The American Drawing-Book (New York: J. S. Redfield, 1858), p. 139.
Chapman's "tesselated" [*sic*] pictorial field provides a foreshortened space
for the introduction of any subject matter the student might choose.

plans (fig. 15) calls to mind such works by Eakins as *Ground Plan for a Portrait of
Dr. William Thomson* (fig. 16).

Chapman even described a process of fabricating the ideal "real" view that seems
a perfect description of Eakins's carefully constructed points of view:

> It will frequently occur, in sketching and drawing from nature, that the artist can
> not place himself at the exact point for viewing his subject under the perspective
> influences in which it may be desirable to represent it. . . . [I]f he were to attempt
> to draw it in the perspective in which he is compelled to see it, no one would recog-
> nise or accept it as a veritable representation. But, he imagines himself at a proper
> distance, as though he were on the deck of a vessel, or some rock placed there
> expressly for his convenience. He satisfies himself with regard to all the points,
> bearings, and proportions of the objects, as though he saw them under such cir-
> cumstances. He regulates the whole by his knowledge of the laws of perspective, as
> accurately as if he stood upon the very spot from which he desires it to be under-
> stood that the view is taken.[30]

Eakins's image of the viewer in his drawing manual (drawing 5, p. 50 below), stal-
wart in his correct viewing position, could well illustrate Chapman's description of
the well-regulated artist/viewer. All these similarities add up to nearly irrefutable
evidence that Eakins developed his perspective system after a close reading of *The
American Drawing-Book*.[31]

While Eakins's paintings and artistic agenda maintain close affinities to passages
in Chapman's text, we should not imagine that he was merely following the *Drawing-
Book*'s instructions. Rather, Eakins's reliance on this text indicates that in Chapman's

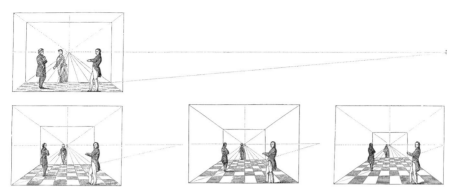

Fig. 12. J. G. Chapman, illustration from *The American Drawing-Book*, p. 147. Chapman promised that even the "least practised eye" would be struck by the effects students could obtain by changing the distance point used to foreshorten the space.

second system, with its emphasis on measured grids and truthful representation, he had found a system of perspective with which he felt comfortable as an artist.

There are certainly sections of Chapman's text, however, that Eakins rejected in both his teaching manual and his artistic practice. The third system of spatial composition discussed by Chapman is less methodical than his first and second systems. Although Chapman maintained that even "marine subjects were subject to the laws of perspective," he also recommended an easier method. As Elliott Bostwick Davis summarizes:

> To achieve perspective in a marine scene, Chapman recommended that the artist establish two constants, the horizon and point of sight. . . . The artist would then draw a vessel of a pre-determined height nearest to the viewer from which he would cast diagonals from the tip of its mast and the bottom of the hull to meet the horizon at the point of sight. The resulting triangular area functioned as a sliding proportional scale by means of which the heights of the other vessels floating further from the viewer could be determined.[32]

Chapman's third system was by no means new. Compositional methods based on geometric patterning were also included in the texts by Harding and Peale. Systems such as these entrust the trained eye to find or construct patterns in nature and do not require any measurements or grids. Eakins undoubtedly would have rejected this method as unscientific, but he probably also would have felt that it relied too heavily on the judgment of the eye—a measuring device Cornu had already demonstrated to be fallible.

Eakins may also have had philosophical reasons for rejecting systems that relied

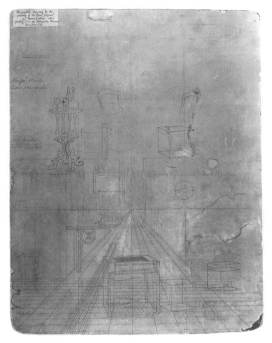

Fig. 13. Thomas Eakins, *Perspective Drawing for "The Chess Players,"*
c. 1875–76. Graphite and ink on cardboard, 24 x 19 inches (61 x 48.3 cm).
The Metropolitan Museum of Art, New York. Fletcher Fund, 1942.35.

heavily on the discretions of the eye, including his preference for artistic efforts that
demonstrate the hard work, and thus the merit, of their creators. At the time
Eakins authored his drawing manual, artistic ideals were changing rapidly, and
even most of the "democratic" art crusaders were moving toward an aesthetic that
embraced less rigorous demonstrations of quality. Many authors, including Peale
and Harding, felt that the purpose of art was to improve and delight the eye and
mind—not to reproduce forms with mathematical accuracy. John Ruskin expressed
similar sentiments in calling for artists to recover "the *innocence of the eye*; that is
to say, of a sort of childish perception of these flat stains of colour, merely as such,
without consciousness of what they signify."[33]

The primary importance that these authors placed on an eye unprejudiced by
prior knowledge of the subject stands in marked contrast to Eakins's recommenda-
tion that students "[s]train your brain more than your eye."[34] And this may well be
the reason Eakins chose to draft his own drawing manual instead of relying on
Chapman. Eakins presented more difficult mathematical subjects in his treatise,
including complex problems in esoteric fields such as refraction, and he offered no

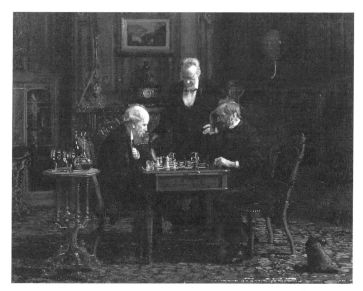

Fig. 14. Thomas Eakins, *The Chess Players*, 1876. Oil on wood, 11³/₄ x 16³/₄ inches (29.8 x 42.6 cm). The Metropolitan Museum of Art, New York. Gift of the Artist, 1881.14.

alternatives for students with little inclination toward algebra. The resulting message of his text—anyone can do this *who works very hard and calculates precisely*—is exactly the type of meritocratic pedagogy promoted at Central High School, whose middle-class students were trained to occupy white-collar positions despite their inability to attend private colleges. Central's meritocratic structure relied on elaborate grading of its students, every day, for both achievement and behavior, a system that generated a precise ordering of students based on excellence rather than social position. Eakins's pictorial subjects were likewise organized according to their numeric values in the perspectival grid, rather than on any more subjective or social qualities.[35]

The perspective system that Eakins ultimately outlines in his treatise is a rich reflection of the artist's convictions, which pervade the well-formed and coherent methods he presents to his students, as well as his own work. Large, elaborate perspective drawings for paintings ranging from *The Pair-Oared Shell* of 1872 (see figs. 3, 4) to Eakins's last full-length portrait, *Dr. William Thomson* of 1907 (College of Physicians of Philadelphia; see fig. 16), all demonstrate the artist's inspired use of gridded perspective. Unfortunately for Eakins, other artists, art students, and even patrons in his day were not nearly so enamored of painting styles based so profoundly on drawing. As Marzio notes,

Fig. 15. J. G. Chapman, illustration from *The American Drawing-Book*,
p. 141. Eakins used squared-off ground plans and elevations to organize
many of his own paintings.

The art crusade died with the men who created it. John Rubens Smith . . . was buried
in 1849. A year before, John Gadsby Chapman traded the noise and rush of America
for the serenity of the Roman Campagna. . . . Most importantly, however, it was the
death of Rembrandt Peale which terminated the art crusade. . . . The art crusaders
may have pioneered the cause of a democratic art but they quickly gave way to new-
comers and specialists. . . . The new generation of professional artists—those who
might have been expected to pick up where Peale and the others had stopped—paid
scant attention to the promotion of drawing. . . . Neither William Merritt Chase nor
Frank Duveneck saw any reason to write or to publish a drawing book. The same
was true for John H. Twachtman, J. Alden Weir and J. Q. A. Ward, all of whom were
famous artists who gained solid reputations as inspired teachers.[36]

By the 1870s, the luster of the art crusade had worn off so completely that William
Morris Hunt, writing in the *Boston Herald*, mocked the most famous of the drawing
manuals: "To draw! What is it to draw? Any idiot who could learn to write could learn
to draw!"[37] The art crusade had clearly run out of steam, along with its cherished
ideals of a democratic art.

In contrast to his peers in the 1880s, of course, Thomas Eakins did write a
drawing book, and its enigmatic combination of scientific dogma and out-of-style
proscriptions for drawing makes perfect sense in light of his philosophical and

Fig. 16. Thomas Eakins, *Ground Plan for a Portrait of Dr. William Thomson*, c. 1907, showing the tabletop and the footprint of the sitter. Pen and blue ink over graphite on buff wove paper, 20^1/$_8$ x 18^{15}/$_{16}$ inches (51.1 x 48.1 cm). The Pennsylvania Academy of the Fine Arts, Philadelphia. Charles Bregler's Thomas Eakins Collection. Purchased with the partial support of the Pew Memorial Trust and the John S. Phillips Fund, 1985-68-33-3.

pedagogical project. Eakins's intention was not to teach in the mode of artists such as Chase or Twachtman, who emphasized the genius of the well-trained eye. Rather, Eakins wanted to provide instruction for students who similarly based their talents on hard work and disciplined study. As a result, Thomas Eakins, stubbornly, unfashionably, dogmatically, holds his place as the last of this nation's art crusaders.

NOTES

I would like to thank Frederick Lane III and Susan Weiner for their generous assistance in the preparation of this manuscript. I am also grateful to Kathleen A. Foster and David Updike of the Philadelphia Museum of Art for their helpful comments and suggestions.

[1] For a general description of the history of perspective, see Martin Kemp, *The Science of Art: Optical Themes in Western Art from Brunelleschi to Seurat* (New Haven: Yale University Press, 1990). Portions of the research for this essay are based on Amy B. Werbel, "Perspective in the Life and Art of Thomas Eakins" (Ph.D. diss., Yale University, 1996).

[2] Peter Marzio, *The Art Crusade: An Analysis of American Drawing Manuals, 1820–1860*, Smithsonian Studies in History and Technology 34 (Washington, D.C.: Smithsonian Institution Press, 1976), p. 1. Marzio's study is the best source of information on the the art crusade. This movement was undoubtedly inspired by a similar adoption of drawing by amateurs in British society a century earlier, chronicled in Kim Sloan, *"A Noble Art": Amateur Artists and Drawing Masters, c. 1600–1800* (London: The Trustees of the British Museum, 2000).

[3] John Gadsby Chapman, *The American Drawing-Book* (New York: J. S. Redfield, 1858), p. 4.

[4] Eakins's "Notes on the Construction of a Camera," included in the appendices to this volume (pp. 101–8 below), can also be considered an effort at applicative utility, as photography was a relatively new tool for artists at the time.

[5] Rembrandt Peale, *Graphics: A Manual of Drawing and Writing* (Philadelphia: E. C. and J. Biddle, 1854), p. 64.

[6] Ibid., p. 68.

[7] For an excellent discussion of this curriculum, see Elizabeth Johns, "Drawing Education at Central High School and Its Impact on Thomas Eakins," *Winterthur Portfolio* 15, no. 2 (Summer 1980), pp. 139–49.

[8] James Duffield Harding, *Lessons on Art*, 5th ed. (London: W. Kent and Co., n.d.).

[9] A. Cornu, *A Course of Linear Drawing, Applied to the Drawing of Machinery*, trans. Alexander D. Bache (Philadelphia: A. S. Barnes, 1840). Bache had been a professor of natural philosophy and chemistry at the University of Pennsylvania and served as president of Central High School and superintendent of Philadelphia Public Schools in 1841–42.

[10] Philadelphia's profitable manufacturing industry was in desperate need of local draftsmen to provide drawings for machinists. For a recent discussion, see Amy B. Werbel, "'For Our Age and Country': Nineteenth-Century Art Education at Central High School," in *Central High School Alumni Exhibition* (Philadelphia: Woodmere Art Museum, 2002), pp. 6–12.

[11] Cornu, *A Course of Linear Drawing*, p. 5. In his drawing manual Eakins uses examples similar to the circular staircase in Cornu's book. See Eakins's drawings 14 and 15 (pp. 65, 66 below) and Cornu's plate 7.

[12] The chief hindrance to greater advancements in large-scale manufacturing in the nineteenth century was, in fact, the problem of sight errors that occurred "in transferring lengths from scales by positioning the legs of the caliper upon the graduation marks." Paul Uselding, "Measuring Techniques and Manufacturing Practice," in *Yankee Enterprise: The Rise of the American System of Manufactures*, ed. Otto Mayr and Robert C. Post (Washington, D.C.: Smithsonian Institution Press, 1981), p. 113. Eakins's methods by no means eliminated the kind of "sight errors" that plagued nineteenth-century manufacturers, but they incorporated influences from mechanical drawing in a uniquely rigorous fashion.

[13] For a recent discussion of Eakins in Paris, see H. Barbara Weinberg, "Studies in Paris and Spain," in *Thomas Eakins*, ed. Darrel Sewell (Philadelphia: Philadelphia Museum of Art, 2001), pp. 13–26.

[14] Marianne Marcussen writes that Monge's descriptive geometry ran on a "convergent course" with the work of Jacques-Louis David ("Perspective, science et sens. L'art, la loi, et l'ordre," *Hafnia: Copenhagen Papers in the History of Art* 9 [1983], p. 70). See also Kemp, *The Science of Art*, pp. 230–31.

[15] Eakins included a representation of this work by Gérôme in his 1876 painting *The Chess Players* (fig. 14).

[16] See Marianne Marcussen, "L'évolution de la perspective linéaire au XIXe siècle en France," *Hafnia: Copenhagen Papers in the History of Art* 7 (1980), p. 63.

[17] Ibid., p. 65.

[18] "La Science de la Perspective est tellement indispensable à l'art du Dessin, que les Peintres, les Sculpteurs et les Architectes de tous les temps ont dû s'appliquer à la posséder parfaitement." Pierre-Henri Valenciennes, *Eléments de perspective pratique à l'usage des artistes* (Paris, 1800; reprint, Geneva: Minkoff, 1973), p. iii (author's translation).

[19] "La science de la perspective, essentiellement liée à celle de l'optique, est une des plus belles applications de la géométrie." David Sutter, *Nouvelle théorie simplifieé de la perspective* (Paris: Jules Tardieu, 1859), p. 1 (author's translation).

[20] Kemp, *The Science of Art*, p. 231. The architects and "professional perspectivalists" employed by Gérôme would have been familiar and comfortable with Monge's methods.

[21] "On était tout simplement en train d'assister à l'aboration d' un nouvelle manière de voir–la perception visuelle–et celle-ci n'était pas géométrique." Marcussen, "L'évolution," p. 70 (author's translation).

[22] Ibid., pp. 56, 63, 70.

[23] Chapman, *The American Drawing-Book*, p. 126.

[24] As Marzio notes, "Chapman's *American Drawing-Book* received the highest praise of all the drawing manuals to appear in the United States before the Civil War. Published in parts from 1847 to 1858, the work contained explicit instructions for both artists and mechanics in drawing, painting, etching, and engraving. The completed version appeared in at least seven editions in England and America, the last being published in 1877" (*The Art Crusade*, pp. 22–23).

[25] Peale, *Graphics*, p. 1; Chapman, *The American Drawing-Book*, p. 1.

[26] Chapman, *The American Drawing-Book*, pp. 126–27.

[27] Eakins and Chapman use the same terminology to describe this grid. Chapman writes: "[E]very one who essays to make a drawing or picture, can readily decide upon these points in advance—the

size of his picture, the *line of the horizon*, and *point of sight*, and lastly the *distance* at which it is to be viewed" (*The American Drawing-Book*, p. 135).

[28] For a thorough and articulate discussion of Eakins's practices, see Kathleen A. Foster, *Thomas Eakins Rediscovered: Charles Bregler's Thomas Eakins Collection at the Pennsylvania Academy of the Fine Arts* (New Haven: Yale University Press, 1997).

[29] Ibid., pp. 141–42.

[30] Chapman, *The American Drawing-Book*, p. 198.

[31] Many other similarities can be found between Eakins and Chapman in areas outside linear perspective. For example, Chapman advises that beginning artists use the brush as quickly as possible: "Facility of drawing may be as readily gained by the use of the Brush as the Crayon. Its power of expression is certainly greater, as well as its means of reaching satisfactory results; the value of which, in stimulating and encouraging the learner, deserves consideration. It is of no use to wait until he has mastered, as preliminary, all the accomplishments of a finished draughtsman, the rules of perspective, and theories of light and shadow; until he possess a perfect understanding of the machinery of the human figure and its anatomical expression; . . . Nor is there any reason that, as soon as he takes the brush in hand, he should discard the pen or pencil" (*The American Drawing-Book*, p. 210). As a teacher, Eakins was a stalwart advocate of the same viewpoint.

[32] Elliott Bostwick Davis, "Fitz Hugh Lane and John Gadsby Chapman's *American Drawing Book*," *Antiques* 144, no. 5 (November 1993), p. 703.

[33] John Ruskin, *The Works of John Ruskin*, ed. E. T. Cook (London: George Allen, 1903–12), vol. 15, p. 27.

[34] Charles Bregler, "Thomas Eakins as a Teacher," *The Arts* 17, no. 6 (March 1931), p. 383.

[35] See Werbel, "For Our Age and Nation" and "Perspective in the Life and Art of Thomas Eakins."

[36] Marzio, *The Art Crusade*, p. 68.

[37] Quoted in ibid., p. 69.

A

DRAWING MANUAL

BY

THOMAS EAKINS

―――――

Director of the Schools

OF

The Pennsylvania Academy of the Fine Arts

―――――

PHILADELPHIA

LINEAR PERSPECTIVE.

Tracing on a Window Pane

ARGUMENT.

A perspective drawing is readily made by tracing on a window pane. Changes are produced by varying the relation of the distances between the eye and the picture plane and the objects drawn. To illustrate the law of these changes, I have chosen a very simple problem and dogmatically assert that the law in this case is sufficient to cover the whole science of perspective, which is of great simplicity and of easy comprehension.

IF ONE SHOULD sit down in a room in front of a glass window, he could if he looked out of one eye only and kept his head still, trace upon the window glass a correct perspective drawing of the opposite houses or other objects outside, by making all the lines of his drawing exactly coincide with the real lines outside: in other words, by making each point of the drawing on the glass part of a straight line drawn from the corresponding point of the real object to the pupil of the eye.

Having made the tracing, he would find that if he moved his head ever so little, his tracing would no longer fit over the real things. If he moved his head upwards, the tracing would go down too low; if downwards, the tracing would go too high. If he stepped back, his tracing would be too small; if he went forwards, his tracing would be too large.

If the objects themselves could be pushed further off from his eye, his drawing would be too large; if brought closer to him, his drawing would be too small.

If holding the head still again and in place, the glass frame could be detached from the window, and the glass brought closer to his eye, his tracing would be too large; if the glass were pushed off further from his eye, his tracing would be too small.

This proves that a picture can be correctly looked at from one point only, and the spectator should have a care to place himself at that point. A picture is in this respect unlike a piece of sculpture.

If the glass frame be put again at its original place, but the upper part tilted towards his eye, then the upper part of his tracing would be too large for the lower

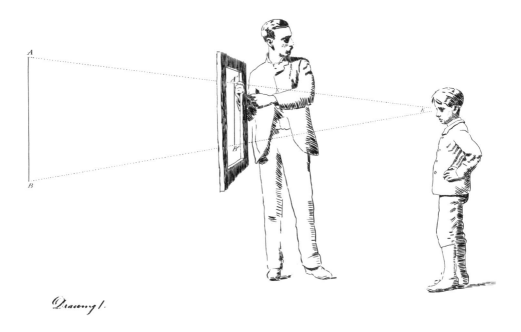

Drawing 1.

part of it; or the upper part might be tilted away from his eye with the contrary result, or one side of the picture plane might be brought nearer to the eye than the other side.[1]

The surface of the glass need not even be plane, but might be curved or bulged or dented or twisted or warped; in fine it might have any shape or tilt whatever and a correct perspective drawing could be put upon it.

The picture surface need not be between the observer and the objects to be drawn, but is often beyond them. The perspective drawing of the objects projected on the picture plane is then larger than the objects themselves.

To discover the exact law of all these changes, let us investigate a most simple case [drawing 1]. Let us take a vertical line, an upright post AB, and place an observer with his eye at E. Drawing straight lines from the points A & B, the ends of the post to his eye, let us see where such lines intersect an upright picture plane (either a plate of glass or a stretched canvas), and then let us compare the size of the real post with that of the picture of the post.

Put the picture plane just halfway between the post and the eye. The picture of the post will be found to be just one half of the size of the real post. $A'B'$ will be half of AB.

To prove this draw from b a line parallel with EA, then the triangle BbC having the same angles as the triangle bEa and the side Bb being equal to bE, the other sides must be equal too, and the triangles are exactly alike. So BC is equal to ba,

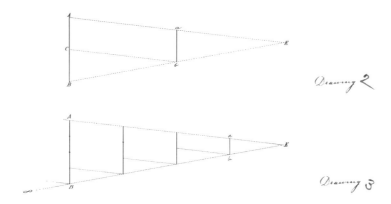

and *CA* is equal to *ba* by construction [drawing 2].[2] Therefore *ab* is one half of *AB*, which we wished to prove.

From which it follows that if the picture plane be put at one-fourth the distance from the eye of the real post, the picture of the post will be one-fourth as long as the real post, and with the same reasoning; and so for every similar triangle added or taken away there is a similar length and a similar depth [drawing 3]. The law then in this case in an upright picture of an upright post, is the law of simple proportion; that is, *As the distance of the object from the eye is to the distance of the picture plane from the eye so is the size of the real object to the size of the picture of this object.*

This is the one and only law of perspective, the law which solves all simple questions of perspective, and to which all indirect questions must be in some manner reduced and fitted before they are solved.

Put the picture plane at the same distance from the eye as the post, then the picture of the post is of the same size as the real object.

If the picture plane be twice as far off from the eye as the post, then the picture of the post is twice as long as the post itself.

The rule for the upright post will apply to a post lying down parallel with the picture plane, or mathematically speaking to any line lying in a plane parallel with the plane of the picture [drawing 4].

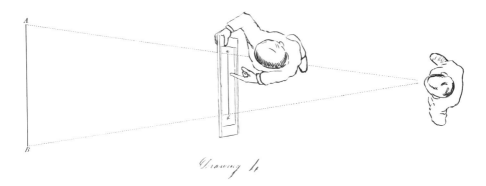

Drawing 4

LINEAR PERSPECTIVE.

Picture Plane Established

ARGUMENT.

The plane vertical surface on which the picture is to be made is established, and
the point of sight defined. It is shown how certain rectangular measurements
taken in the three dimensions of nature may be transferred to the picture plane
and the student is engaged to remember the simple directions in which these
original dimensions are always to be measured.

WHEN A PICTURE is made it is a thousand to one that it is on a flat surface, and
intended to hang on a vertical wall; and a person wishing to see it, will stand
opposite the middle of it, and look squarely at it (drawing 5).[3] We may therefore
dismiss as unnatural the oblique perspective of the book makers,[4] and for the
present at least all surfaces except flat ones;

> **for even if it were required of us to put the perspective drawing on a tilted,
> warped, curved, or twisted surface, or any surface other than a vertical plane one,
> the best and shortest way would be to make the drawing first upon a plane verti-
> cal surface, and then, considering the given surface as a variation from the plane
> vertical surface, to distort properly the simple drawing to suit that variation.**

Having found or arranged some objects of which you wish to make a picture (or
imagined them), and having placed yourself so as to see them as you wish to repro-
duce them, you must notice where the middle of your field of vision is and fix it by
some mark if possible on one of the objects or on a wall beyond, or on the floor
directly under the middle of the field of vision.

Then draw a vertical line down the exact middle of your canvas or drawing
paper to fit over the middle of your field of vision when your picture shall be held
up in place. At right angles to this vertical line & passing through it draw from one
side of your canvas or paper to the other a straight line to represent the horizon or
height of the eye; and now your picture plane is fixed except its distance forwards
of the eye.

To fix this last distance you consider how large you want one of your important objects to be in the picture: if you want it life size in the picture, your drawing must be distant from the eye as far as that object. If you wish any object to be in the picture half as big as it really is, you must place your picture plane at half the distance from the eye of that object; if quarter as big, quarter the way & so on.

THE CROSSING OF the horizon line and the middle vertical line on the picture is called the point of sight, and is the point of the picture just opposite the eye, and nearer to the eye than any other part of the picture plane, and is the point to which you measure in settling the distance of the picture from the eye.

So that if I say, such a picture is 3 feet from the eye, I mean it is 3 feet from the eye to the point of sight on the canvas, not 3 feet to the more distant corners or other places on the picture plane.

YOU ARE NOW READY to measure the place of any point in nature in the real objects before you, and put it in correct perspective on the plane, by taking three measurements for such a point and these the most simple rectangular ones. You measure how far such a point is directly forward of the eye along the middle line; then how far it is to the right or left of the middle line, and lastly how far it is up or down from the level of the eye. Let us proceed to an example.

Proposition. A point is 12 feet forward of the eye, and 2 feet below the level of the eye, and 1 foot to the right of the centre of vision. Find on a perspective drawing to be held 1 foot from the eye the correct place of such point.

Draw on your paper a horizon line and a middle vertical line. The picture being 1 foot forwards of the eye while the point is 12 feet forwards is $\frac{1}{12}$th as far off as the point.

The point lies 1 foot to the right of the centre. The picture of a line a foot long parallel with the picture plane and 12 times as far off as the picture is $\frac{1}{12}$th as long as the foot or 1 inch. So measure off an inch to the right of the centre C along the horizon to the point A. (See drawing 6.)

Again the point is 2 feet below the level of the eye. The picture of the line 2 feet long & 12 times as far off as the picture is $\frac{1}{12}$th as long as the real line; to wit, 2 inches long. So measure down 2 inches from C to B.

Then the picture of the point is as far to the right of C as A, and as far down from C as B. Draw the coordinates AX & BX which by intersection will give X the point required.

Example for practice. A perspective drawing is to be made to be seen 3 feet off from the eye. Draw your horizon and central plane and represent a point in nature

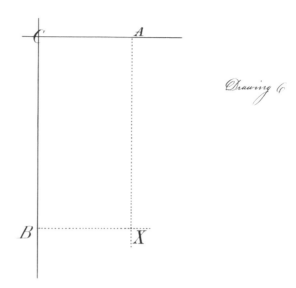

Drawing C

18 feet forwards (6 times as far forwards from the eye as the picture), 18 inches above the horizon & 1 foot to the left of the centre.

YOU NOW READILY perceive that by a series of such measurements, we could point by point construct a perspective drawing of anything which we could measure.

You can see too how to overcome the difficulty of drawing a slanting post, which does not come directly under our universal perspective rule.

We would measure its top point first, how far off from the eye, how far up or down from the level of the eye, how far to the right or left of our central plane, & then put it in perspective. Then we would measure the bottom point in the same way, and construct it; and having the picture of these two points of the slanting post, we would draw a line from one to the other for the picture of the post.

THE CONSTRUCTION of a large picture by separate points chosen indiscriminately and measured first in nature, and then on the paper after calculation, would be tedious and laborious.

So the rest of our perspective will be an investigation of a choice of points, and of economy of our labor.

If we find two points of a straight line, a ruler laid through them will give us all the other points of such a line and it would be foolish to find by separate measurements any more than two of its points. A few lines intersecting each other give by their intersection many new points which may be made the starting points

of a multitude of new lines; and so on: but have it clear in your mind in using these secondary lines frequently that they are conveniences, not principles.

The first measurements of the points in the three rectangular dimensions, how straight forward of the eye, how far up or down from the eye, how far right or left from the middle, and the transfer of these last two measures to the paper as affected by the first according to the single rule of three; these, these only constitute the principles.

LINEAR PERSPECTIVE.

Theory of Vanishing Points

ARGUMENT.

The general theory of vanishing points is explained and use is made of them to quickly construct a view of the surface of the floor all covered with squares a foot each in size, checker-board fashion.

This picture of square feet at all different distances forms a most convenient scale for the construction of the objects in the picture, and is hereafter always made use of in perspective problems.

The device of the little squares is explained & made use of, and its accuracy proven.

A LINE DRAWN from the eye to any part of the picture plane would, where it pierced the picture plane, give the vanishing point of all lines parallel with the line thus drawn; for, no matter what might be their distance apart (measured for simplicity's sake by lines parallel with the picture plane), the picture of their distance apart twice as far off as at any chosen point would be twice as small as at that chosen point; the picture of their distance apart a hundred times as far off, a hundred times as small, a million times as far off, a million times as small and so on, and anyone can see in nature that the long parallel lines like those of a straight street & its houses & sidewalks, like those of a long bridge, like those of a straight stretch of railroad seem to converge in straight lines towards a distant point.

As the point of sight is the point of the picture placed directly opposite the eye, the point of sight is the vanishing point for all lines perpendicular to the picture plane.

The vanishing points for angles of 45°, that is for lines sloping like the diagonals of a square on the floor, two sides parallel with the picture, would be as far to the right or left of the central plane as the picture is forward of the eye.

LET US APPLY the principle of the vanishing points to the quick solution of a problem of great utility, to wit: Make a picture of a number of square feet marked

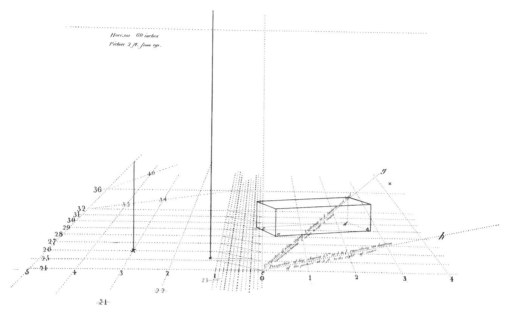

Drawing 7

upon the floor, checker-board fashion, the squares to be parallel with the picture plane, the floor to be level and 5 feet below the height of the eye; the picture to be held 2 feet in front of the eye.

Draw on your paper at right angles to each other the horizon and centre line. (See drawing 7.)[5] Find on the centre line the corner of some square. Let us find the corner 24 feet from the eye, which will give us no fractions.

This is the same problem as finding the picture of a stick 5 feet long, 24 feet off, upright, the top of it level with the eye. The lower end of it would then touch the floor 24 feet off.

Well, 24 feet off is 12 times as far from the eye as the picture, which is to be 2 feet, so the picture of the stick is $\frac{1}{12}$ th of 5 feet or 5 inches long.

So measure down from the point of sight along the central line 5 inches, and through this lower point draw a line across the picture parallel with the horizon for the picture of a line 24 feet forwards, parallel with the picture & number it 24.

The picture of real feet measured off on the 24 foot line to the right and left of the central plane, would be represented in the picture (12 times as close) by inches: so mark off inches in your picture to the right and left on your 24 foot line, and number them as feet to the right and left, calling the middle line 0. Draw from all these divisions on the 24 foot line, straight lines to the point of sight, for those

sides of the squares perpendicular to the face of the picture.

To get the other sides to the squares we shall use a little device. We will draw diagonals. Let us choose diagonals running forwards to the right. They must vanish on the horizon (the floor is level) at a point 2 feet to the right of the centre. (See drawings 7 & 4.)[6]

In the present case let us draw our diagonal from the picture of the point we first found: namely the one 24 feet off, 5 feet off [i.e., below eye level] and 0 right or left, up to the vanishing point on the horizon 2 feet from the centre.

After our diagonal, leaving the 0 x 24 feet intersection, has travelled 1 foot to the right it has gone also 1 foot forwards & the first intersection marks then a point 25 feet forwards from the eye, through which point draw the 25 foot line. At the next intersection having gone 2 feet to the right it has travelled 2 feet forwards & we there have the place of the 26 foot line, and so on. From any of the last lines found, we may from any corner over to the left run a new diagonal to the same vanishing point to give by their intersections new distance lines as far as may be wished.

If we prolong our diagonal & foot lines backwards from the 24 foot line, we can find by intersection the 23 foot line, the 22, 21, 20 &c.

But it is not well to go far backwards deducing large dimensions from small ones, as unavoidable errors become magnified.

THE PICTURE OF THESE squares numbered as feet, forms the best possible scale for the construction of a perspective drawing.

You can now find the place on the picture of the floor of any objects set upon the real floor by drawing them in their proper squares.

Example. Find on the perspective scale of square feet just drawn a spot on the floor 26 feet forwards of the eye, 3 feet to the left of the middle line, and put a little cross there.

Example. Raise a perpendicular there, and make it 2 feet high.

To do this take with your dividers 2 feet along the 26 foot line as a scale, and erect it, both lines lying parallel with the picture plane. So all vertical distances too are measured by the horizontal scale we have constructed.

You see now how rapid this process is in comparison with finding out each point by original calculation.

A FOOT THOUGH is rather a coarse measure for fine things, so we had better divide up some of the square feet into inches. Let us take the foot on the 24 foot line from 0 to 1 left, and divide it into 12 equal part to represent inches, and run lines from the divisions up to the point of sight. This gives us the apparent size of inches

Drawing 8.

at all distances from the eye.

Again draw diagonals across these feet to be able to measure inches forwards from the eye as well as sideways. (See drawings 7 & 8.)

Example. Find the place in this same picture, of a point on the floor 25 feet 3 inches forwards, & 1 foot 2 inches to the left of the middle line.

Where the diagonal of the square foot 24 x 0 to 25 x 1 left, goes through the 3d inch it has travelled 3 inches beyond 25 feet. Draw then a lead pencil line horizontally through this intersection & measure on this line the 1 foot 2 inches which is to be laid off from the middle to the left.

Example again. On the point just found raise a perpendicular 65 inches high.

To get this, measure your 65 inches on the lead pencil line (for that line is the scale for things in the plane of the picture & 25 feet 3 inches forward of the eye).

Then raise it from the floor; or draw an indefinite perpendicular & measure only the 5 inches on your scale which apply to your perpendicular up from the horizon which is already 60 inches.

You may notice in the scale, that I have ruled every 3d inch division heavier than the others to facilitate counting.

Another example. Find on the perspective drawing, a point 27 feet 5 inches forward of the eye, 3 feet 1 inch to the right and 17 inches high from the floor.

Another example. Here is the ground plan (drawing 9) or top view of a brick shaped box which you may put into perspective on the plan just drawn (drawing 7) that is in a picture 2 feet from the eye, horizon 5 feet.

The box is 32 inches long, 16 inches wide, and 8 inches high, and is to lie flat on the floor, at the angle which I show you in the ground plan (drawing 9) which I have made $\frac{1}{12}$th the natural size or to scale $\frac{1}{12}$th.

A ground plan is a map of anything looking down on it, drawn to any convenient scale, and should almost always be drawn on paper before putting things into perspective.

I shall show you how to construct the ground plan I have made (supposing the object & circumstances to be real).

First I should stretch a string along the floor from under my eye, along the floor in the direction of my central plane.

Measuring on the floor the nearest corner of the box (*a*) I find it to be 28 feet 1 inch forward of the eye, 4 inches to the right of the middle, and I mark its place on a scale of square feet which I have already drawn on paper to some convenient scale.

Now let us get another corner, the point *b*. We could proceed again and measure along the floor from under the eye, but a better way would be to draw the 28 foot line across the floor or stretch a string, and then to measure from that. This would save us going twice with a foot rule over all the space between 0 & 28.

Measuring the place of the corner *b*, we find it 1 foot 1 inch further forward than the 28 foot line, or 29 feet 1 inch forward, & 2 feet $9\frac{3}{5}$ inches to the right.

We could now go on and find a third point in the same way, but the second point has given us the direction of a side of the box, and now it is shorter to construct on paper the box on its own axes, just as the man constructed the real box, that is to draw the two adjacent sides at right angles to *ab* and make each end 16 inches wide & from the ends of them to draw the 4th side.

Now not only is it more rapid to draw a thing as the man has himself made it, that is in its own axes of construction, but it is also a more exact & natural way, the parts being rigidly connected, than to construct by separate & independent measurements from outside plans. With a protractor we could have measured the second point found, *b*, in another way. Laying it parallel to the 28 foot line we could have read in degrees how much the side *ab* sloped, which slope imitated on the

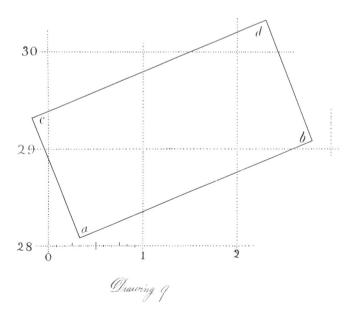

Drawing 9

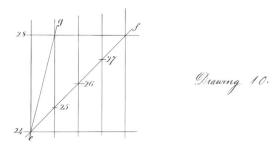

Drawing 10.

paper, we could have laid off from *a*, the 32 inches to *b*.

The points *c* & *d* you get by construction on paper by making the box rectangular with ends 16 inches long.

You can then in the ground plan with one of the feet divided up into inches, measure there how far *c* is to the left of the middle plane & how many inches it is beyond the 29 foot line, also where the *d* point is by the rectangular dimensions used in perspective; that is how far straight forward of the eye, or how many inches beyond the 30 foot line; how far to the right of the central plane, or how many inches to the right of the 2 foot line.

These points as soon as known in their rectangular perspective dimensions, can be transferred readily to the perspective scale, & to complete the picture of the box, you raise perpendiculars from each corner of the box *abcd*, each 8 inches high, each 8 inches measured horizontally on the part of the perspective scale on which that particular corner rests.

In drawing the perspective scale of square feet a while ago, we used the principle of the distance point or vanishing point of a diagonal making an angle of 45° with the picture plane. Now this vanishing point, so handy otherwise, has the inconvenience of being so far to the side of the centre that it is far outside the paper you are drawing on, unless you draw wastefully on a piece much larger than you need for your picture; for no one makes a picture as wide each way from the centre as the whole distance of the picture itself from the eye.

To avoid this difficulty a new device suggests itself. If after establishing our picture plane & determining our first point on the floor, which in the last case was 24 feet forwards, we had sought the vanishing point of a line sloping much less than the diagonal, say as the line *eg* (drawing 10) which slopes 1 foot to the right for every 4 feet forward, then we would have the vanishing point within our paper. A line sloping from the eye 1 to 4 would strike the picture plane $\frac{1}{4}$th as far to the right or left of the centre as the picture is distant from the eye.

If we had not used the diagonal in the last plan (drawing 7), but this line 1 to 4, it would have gone 4 feet forward from 24 or to 28 feet, when it had travelled 1 foot to the right, and horizontal lines through the intersections would not have given us squares, but rectangles 4 times as deep into the picture as wide, but by taking 4 of these figures side by side we get a square, and a diagonal then drawn will give us the intermediate feet by intersection. (See drawings 10 & 7.)

Even a line 1 to 4 runs sometimes outside the paper & then a line 1 to 6 or 1 to 8 is preferable.

Let us apply now the new plan to a problem. I am sitting with my eye 48 inches above the floor. (See drawing 13.) The picture plane is to be $1\frac{1}{2}$ feet forward of the eye. Draw the perspective plan of a number of square feet marked upon the floor parallel with the picture & in the neighborhood of from 20 to 30 feet, where I wish afterwards to place some principal objects.

Draw the horizon and middle vertical line, and let us start from a point upon the floor 18 feet off from the eye; that is 12 times as far as the picture, and then mark on the middle vertical line of the picture 4 inches down for the picture of this point, because an upright stick 48 inches long from the level of the eye to the floor & held off at 18 feet would be represented on the picture by a line $\frac{1}{12}$ of 48 inches long or 4 inches long. The horizontal line through this lower point is then divided right & left into inches representing feet, and one of the last divisions into twelfths to represent inches.

We could have started to get first the 20 foot line instead of the 18 foot one; 20 feet is $13\frac{1}{3}$ times as far off as $1\frac{1}{2}$ feet, the distance of the picture, and the picture of the things at that distance would be $\frac{1}{13\frac{1}{3}}$ as big as the real things, so that a foot would be represented by $\frac{1}{13\frac{1}{3}}$ of 12 inches. Now this fraction would be inconvenient to measure and unnecessary.

It is therefore generally best in making the start of a perspective plan to take some multiple or measure of 12. Say start a line 12 times as far off as the picture where feet will be represented by twelfths of feet or inches, or 24 times as far when the picture of feet will be half inches, or 8 times as far when feet become $1\frac{1}{2}$ inches, or 6 times as far when a foot will be represented by 2 inches, or 4 times when 3 inches will stand for a foot, and so forth.

Coming back to our drawing and commencing at 18 feet for the good reason just mentioned, draw the 18 foot line $\frac{1}{12}$ of 48, or 4 inches below the horizon, and mark off inches on it right & left, & call them feet, and through these marks draw straight lines up to the point of sight. Then at a distance on the horizon from the point of sight equal to $\frac{1}{4}$th of the distance of the picture from the eye, $\frac{1}{4}$th of 18 inches, make a mark for the vanishing point of lines sloping 1 to 4.

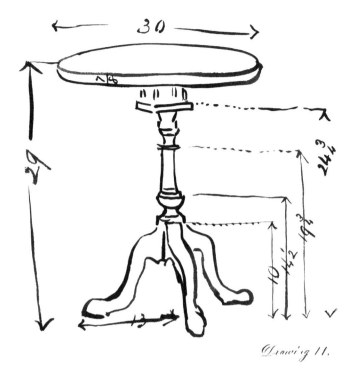

Drawing 11.

Drawing a line to this point from any corner of a square, say at 18 feet the next intersection will be 4 feet further on and will give the place of the 22 foot line, the next intersection the 26 foot line and so on. A diagonal drawn through a square composed of 4 of these rectangular figures laying side by side will give the intermediate feet.

Make an inch division so as to be able to measure accurately and expeditiously, and then make a correct perspective drawing of a round top table of which I give you the sketch. (See drawing 11.)

Let it rest on the floor with its centre over a point 21 feet 2 inches forward, 2 feet 5 inches to the right.[7]

The sketch you make of anything to be put in perspective should always be figured by measures of the principal parts, and to choose the principal parts we must follow the mind of the cabinet maker who constructed it. He wished a table 29 inches high & 30 wide with 3 legs spreading 13 inches from the centre to give it just that much steadiness.

The thing now to do is to draw to any convenient scale, a ground plan of the table & of the subjacent & adjacent square feet, and then transfer points of the drawing from the ground plan to the perspective plan & erect perpendiculars from them to the required height.

But before making the transfer I must show you a most useful method of drawing all curves and other complex forms. (See drawing 12.) This is to enclose

2 ft.

Drawing 12.

such a complex form in the most simple form, which simpler form being put into perspective easily, we lop off the superabundant parts.

To draw the table top, a circle, let us in the ground plan circumscribe a square parallel with the picture plane, and then let us transfer this square to the perspective plan, first on the floor, and then raise it to the proper height by the 4 corners one at a time.

Now let us cut up the circumscribing square in the ground plan & perspective drawing into an equal number of little squares. Let us choose 64, the same as a chess board has. Divide two adjacent sides of the ground plan square into 8 equal parts & parallel lines from the divisions will complete the 64 little squares.

To divide the perspective one, divide the nearest side of the square parallel with the picture plane into 8 equal parts, & from the divisions run lines up to the

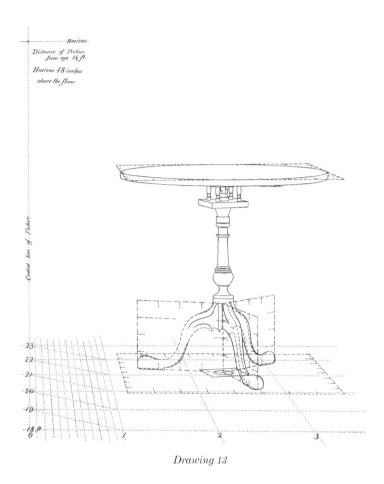

Drawing 13

point of sight. A diagonal will then give the horizontal divisions by intersection. (See drawings 13 & 12.)

Now you can copy by eye, from the ground plan to the perspective drawing, the curve running through the little squares.

But if this drawing of the curve should then be not fine enough, we could easily divide the sides of the squares into 16, 32, 64 or as many parts as could easily give the required accuracy: and you need not imagine there need be any want of accuracy in this method of copying by eye from one set of little squares to the other set, the perspective set; for no matter if the eye itself should be so inaccurate that it would put a point in a little square as far as possible from its true place; yet by increasing the number of little squares, and so diminishing their size, a possible error can be made less than any given amount.

Drawing 14

To avoid complications, it is well in all extended drawings to use three different inks, a blue ink for instance for the square feet marks in the ground plan and for the picture of these square feet in the perspective plan, for the horizon, & middle line; in short, for all the purely perspective scale parts; secondly, a red ink for axes of construction or simpler figures enclosing the complex ones not sought directly; and finally black ink for the finished outlines.

In the illustrations (debarred from color) I make dotted lines, broken lines, & full lines.

I think you might now by yourselves draw a circular or spiral staircase. Let the eye (drawings 14 & 15) be 44 inches from the floor. Let the picture be 3 feet from the eye. Let the centre of the staircase be 41 feet 3 inches forward of the eye, 0 feet & 7 inches to the right of the middle. The diameter is 7 feet, the round post in the middle is 6 inches thick. There are twelve steps in the circle going up to the left like a screw thread, and I give you the ground plan parallel to the picture plane. You see there is no step parallel with the picture plane, and I give you the ground plan to show you the angle, and I have numbered the steps to show you where to begin. Each step is to be 7 inches high.[8]

I have drawn also the axis of the hand rail. Measure how high I have drawn it, & then construct it yourselves.

This is substantially a similar problem to the round top table. Enclose your circle in a square, put it on the floor in perspective together with the twelve divisions

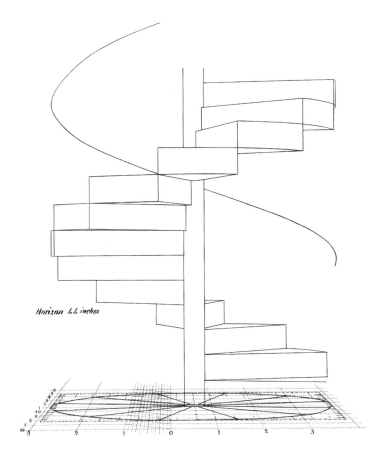

Horizon 44 inches

Drawing 15

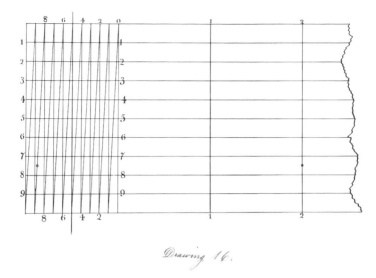

Drawing 16.

into steps by means of the little squares; then go around building up step by step 7 inches for the first, 14 for the second, 21 for the third & so on.

To draw well and expeditiously you should have a drawing board with straight edges at right angles, a T square to run along the side of this board & give you parallel lines, a pearwood ruler with angles 90°, 60° & 30°, a scale with inches & parts of inches, and a pair of dividers. Sharpen your pencils to chisel edges to make them last when you are ruling lines.

To measure small parts of an inch you should have a diagonal scale, or make one on paper by dividing an inch in 10 equal parts, drawing lines at right angles through these divisions & marking off 10 divisions on these last lines. Diagonals then drawn from the tenths on the top line to the next tenths on the last line will in traversing the whole distance gain the 1 tenth by regular stages of tenths of tenths or hundredths. You can thus accurately measure hundredths of an inch with your compasses, and estimating between the tenths across the scale you can estimate very closely to the thousandths of an inch.

I have drawn such a scale (drawing 16) and marked by two little circles have enclosed a distance of 2 inches, 8 tenths, 7 hundredths, & 5 thousandths, 2.875 inches.

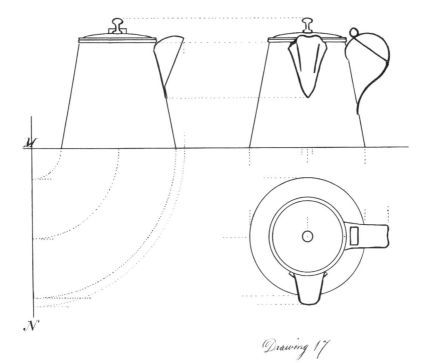

Drawing 17

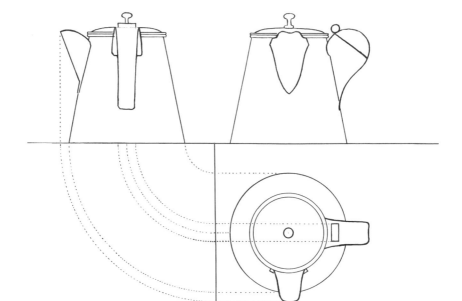

Drawing 18

MECHANICAL DRAWING.

ARGUMENT.

The manner of mechanical drawing is shown by draught of a common utensil, and the simplicity of the measurement is explained as compared with perspective measurements.

The actual measure of a thing is given and it is then tilted in mechanical drawing to get its new height &c. & it is then put into perspective.

A device is shown for dividing up properly the picture of any line: also the geometric device for dividing a line itself into equal parts.

MECHANICAL DRAWINGS are made to scale and represent different planes of which the principal ones are 3: the ground plan, or top view; the side elevation; and the end elevation, or end view, all 3 at right angles with each other.

When drawings of a machine in these 3 dimensions are not sufficient for the explanation of its construction, then sections are made, usually still parallel with these first dimensions, for machinery is mostly constructed right angled in its principal parts, though an oblique construction may compel the draughtsman to use other planes.

Drawing 17 is a mechanical drawing of a common tin coffee pot properly placed for drawing with its construction axes in the construction planes.[9] The dotted lines are coordinates showing the connection between the same points in the different planes.

The end view plan (drawing 17) is drawn as for a spectator looking from off our left towards the pot. This manner of drawing an end view is the usual practice in the American workshop, and mostly in England, but a Frenchman or other continental European would conceive the end view drawing as made by a spectator from the other side of the pot. So the Frenchman would have, if he drew his end view on the same side of the elevation that we have it, the view of the handle & with the spout on the left instead of the right, as in drawing 18.

Of course there is no essential difference in the two ways of drawing & there is little choice for investigation or your own work; but in a workshop, where the

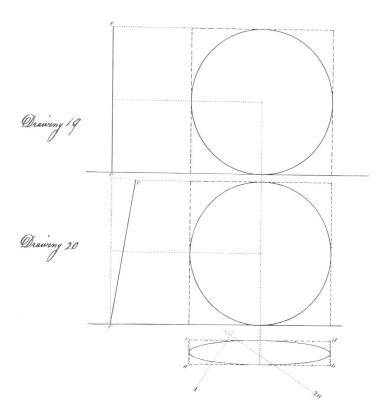

Drawing 19

Drawing 20

draughtsman designs the machine & others make it, one or the other method must be adopted & the other rigorously excluded, or there will be continual misapprehensions & left handed things made. To be perfectly consistent my ground plan or top view (drawing 17) should have been above the elevation, but I do not think that this yet prevails except in a few very advanced shops.

Mechanical drawing is simpler than perspective. Its scale is not continually changing to show changes of distance from the eye. A perspective drawing would give a workman the best notion of the looks of a thing, but he could not measure from it as from a mechanical drawing.

This facility of measurement in mechanical drawings is of the greatest advantage to us if we wish to cast shadows, or change the slope of a thing; but an example will best illustrate its use.

A little boy is trundling a hoop & turning a corner so that he tilts the hoop. Make a perspective drawing of the hoop. The hoop is to tilt over at an angle of 1 to 6, that is 1 to the right for every 6 upwards. It is 3 feet in diameter. It is to slope away on the pavement at an angle of 2 forwards for every 3 to the right. The point of the hoop

that touches the pavement is 26 feet 3 inches forwards of the eye, 1 foot 7 inches to the right of the centre. Let the eye be 66 inches above the level of the pavement, and the picture 2 feet forwards of the eye.

In drawing 19 I show you first a side view & to the left of it, an end view of the hoop. I did not draw the ground plan which would have been a straight line. In drawing 20 I have taken the end view and tilted it over at the required angle 1 to 6. This has lessened, you see, the height of the top of the hoop from the ground, and I have drawn you the side elevation again (by means of little squares). It is no longer a circle but is somewhat flattened into an ellipse. I have also drawn now the ground plan, another ellipse, whose width measured in the end elevation is the distance that the point *e* has been taken away from the vertical. I have also in the ground plan (drawing 20) drawn the 26 foot perspective line & 1 foot to the right perspective line at the given place & slope.

A simple box with ground plan *abcd* & of the height *e* measured vertically, will be very easily put into perspective and then may be cut up & the superabundant parts lopped off. Drawing 21 shows the manner of doing this. The box being set up, the plane containing the hoop runs from the back lower edge *cd* of the box to the near upper edge *ef*, & this plane is the perspective representation of a square circumscribing the hoop or circle. To divide this square up into little squares, we meet a difficulty. No edge of this square lies parallel with the plane of the picture & we cannot divide it up directly. The edges *ae*, *cg*, *bf* & *dh* of the box however are in the plane of the picture, & they can be divided up one at a time. Lines through these divisions in *ae* to those in *cg* & from those in *bf* to those in *dh*, will by intersecting divide up *ce* & *df*, and then lines from the divisions in *ce* to those in *df* will divide the big square one way, & diagonals will enable you to divide it the other way, and the curve is drawn then as in the circular table. Of course there was no necessity of drawing the projections of the curve in the ground plan & side elevation of drawing 20. I only did it to make the drawing clearer.

You can see I think from the above example the use of the simpler measures of the mechanical drawing in preparing for the perspective. It would have been very difficult to have drawn the hoop in perspective & then to have tilted it.

If our problem had been to draw the hoop falling down & almost down to the ground so that the rectangular figure enclosing it would have been one of but little height (or we had had any other similar problem), it would be unwise to commence cutting up our big square on the line *ae*, for then we would be deducing big measures from little ones.

Let us suppose that we would rather cut up first our line *cd* or *ab* [to derive] the ground plan of *cf*. Of course it could be done by making the divisions in the ground

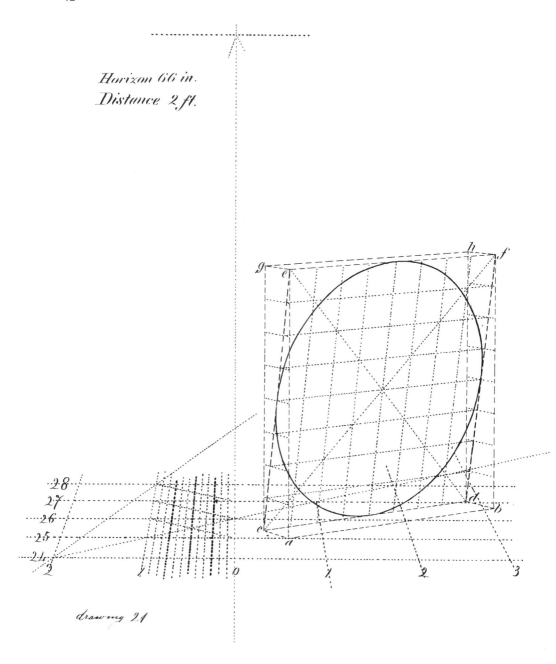

Horizon 66 in.
Distance 2 ft.

drawing 21

plan and then measuring the spot of each division & transferring it, but another way
is by the intersection of parallel lines, often quicker and more direct.

Let $a'b'$ (drawing 22) be the perspective of a line lying flat in the plane of our
ground plan, but sloping away from the picture. ab is the ground plan of the same
line. Now if in the ground plan, parallel lines in any direction are drawn through the

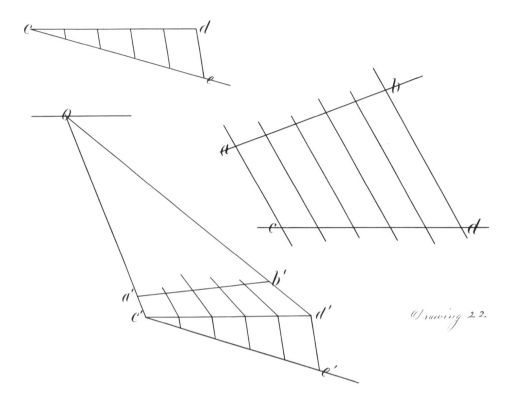

Drawing 22.

ends of this line, and meet another line *cd*; and we divide up this latter *cd* into any number of parts, & run back from the divisions, lines parallel with *ac* & *bd*; then will *ab* be divided similarly to *cd*. So, as in the perspective drawing, parallel lines on the floor will vanish at the horizon, we draw from any point on the horizon as 0 a line through *a'* & another through *b'* until it meets some line as *c'd'* parallel with the plane of the picture. This *c'd'* then divided up in any manner, the picture of parallel lines (that is lines meeting on the horizon) will by their intersection divide up the line *a'b'* into the picture of a line with similar divisions to those of *c'd'*.

When the line to be divided up does not lie on the floor, take its ground plan, divide it there & erect perpendiculars from the divisions to give by their intersections the divisions on the line sought.

In the last problem, to get the picture of 5 equal divisions in the line *a'b'*, we divided in 5 actually equal portions the line *c'd'*. This operation is often done by simple continued approximation with the dividers, but where the numbers are large & prime, it becomes tedious. The dividers adjusted, & the distances stepped off, the line is too long; the dividers are slightly closed and the line stepped off &

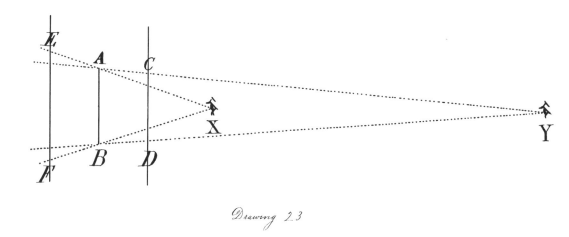

Drawing 23

perhaps it comes out as much too short as it was too long before. It is then better to have recourse to a geometric device.

From one end of the line $c'd'$ as from c' draw a line sloping somewhat away from the original line & on this secondary line set off with your dividers the number of the divisions you wish, guessing at their size & letting them come out as they may, long or short. Join the end of the last division as e' with the other end d' of the original line, & then from the guessed at divisions draw lines to $c'd'$ parallel with $e'd'$ & $c'd'$ will be evenly divided into the required number of parts.

Drawing 23 explains well I think the difference between a mechanical & a perspective drawing. Let AB be an upright line, CD a picture plane nearer the eye than the line AB, & EF the trace of another picture plane further from the eye than the line AB. The eye being placed at X the picture of AB on the plane CD would be much smaller than AB while the picture of it on EF would be much larger.

If however the eye be taken back to the position Y, the two pictures of the object would be much closer in size to the object itself and to each other than before. By continually increasing the distance of the eye, the lines from the eye to the ends of the object become more & more nearly parallel & may be made to differ from parallel lines by an amount smaller than any given amount. Now mechanical drawing being made with parallel projection, we may say that mechanical drawing is the limit of perspective drawing when the eye is infinitely far away.

I know of no prettier problem in perspective than to draw a yacht sailing. Now it is not possible to prop her up on dry land so as to draw her or photograph her, nor can she be made to hold still in the water in the position of sailing. Her lines though, that is a mechanical drawing of her, can be had from her owner or her builder, and a draughtsman should be able to put her in perspective exactly.

A vessel sailing will almost certainly have 3 different tilts. She will not likely be

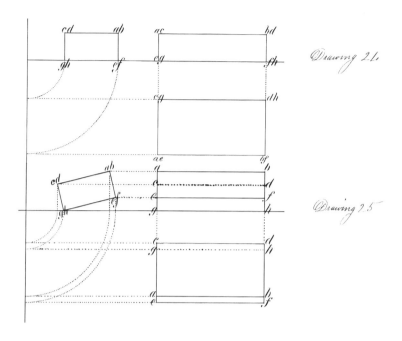

Drawing 21.

Drawing 25

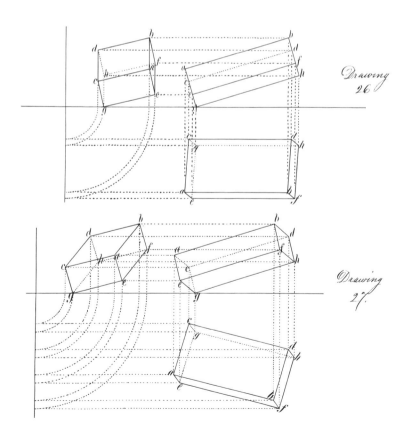

Drawing 26

Drawing 27.

sailing in the direct plane of the picture. Then she will be tilted over sideways by the force of the wind, and she will most likely be riding up on a wave or pitching down into the next one.[10] Now the way to draw her is to enclose her in a simple brick shaped form, to give in mechanical drawing the proper tilts one at a time to the brick form, and finally to put the tilted brick into perspective and lop off the superabounding parts.

Here then (drawing 24) is a brick shaped body, twice as wide as high, twice as long as wide. It is here parallel with the planes of projection and I have lettered the corners so as not to lose them, and I advise you to take a real brick or a pasteboard box of similar shape, & letter the corners, and keep it by you while you draw it.

We shall make the first change by tilting it in the end view plane, keeping *gh* in place but raising *ef*. (Drawing 25 from drawing 24.) Drawing coordinates from our new end view, we deduce the new side elevation and new ground plan.

Let us next in the side elevation tilt up the *bh* end of the box leaving the point *g* on the ground. (Drawing 26 from drawing 25.) Complete the ground plan & end elevation by means of coordinates.

Lastly give the brick a final tilt in the ground plan (drawing 27 deduced from drawing 26) keeping the point *g* as a centre, swinging around the end *dhbf* towards us.

Find by coordinates the new positions of the points in the side elevation and end elevation, and we now have in mechanical drawing in the three rectangular planes of ordinary projection a picture of a brick tilted to all of them.

If in practice we had tilted this brick for perspective purposes only, we could have omitted drawing 27 except the ground plan, for the heights suffered no change from drawing 26. Indeed we could have omitted the ground plan too, dispensed altogether with drawing 27, by turning in drawing 26 the ground plan of the square feet under the brick as I did in the ground plan of drawing 20 of the hoop.

You see that in our drawing of a brick there are always 4 lines parallel with each other. An expert would therefore have selected but 1 of each to give the tilts with, & then would have added the others. In fact it is likely he would not have got the tilts by drawing at all, but would have figured them out from trigonometric tables, but it is much easier for beginners to understand solid things than mere lines of direction.

ISOMETRIC DRAWING.

ARGUMENT.

Isometric drawing is a manner of drawing, which partaking somewhat of the appearance of perspective, yet has a very simple measuring scale.

To PUT A THING in isometric drawing we make of it a mechanical drawing in the picture plane of the elevation; but so tilt the thing in drawing it, that its three rectangular axes may all tilt equally to the picture plane; may consequently all be foreshortened to the same extent, and that a single scale may be applied to all lines parallel to the rectangular axes of the construction of the object. As almost all things that folks make are constructed in the three rectangular dimensions, isometric drawing has a very extended and useful application.

Let us take a cube (drawing b¹) and make its ground plan, side, & end elevation.

Let us now in the ground plan turn the cube so that (drawing b¹ [center]) its edge *dh* may be exactly behind the edge *ae*, and deduce the side & the end elevation.

Lastly (drawing b¹ [right]), let us in the end elevation tilt up the cube on its point *e* until the point *h* may lie directly behind the point *a*, and then deduce the ground plan & side elevation.

This last side elevation is the isometric drawing of the cube, and you see that the lines *ab cd*, *ef*, *db*, *ca*, *ge*, *bf*, *ae*, *cg*, all the sides of the cube are equal.

You will notice the outline of the isometric projection of the cube is a regular hexagon.

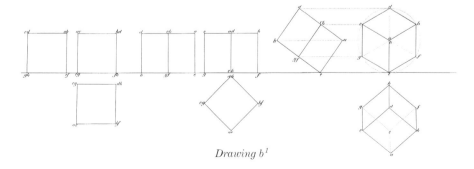

Drawing b¹

As the cube (cubic foot, cubic inch, or cubic metre) is the measure for all solid bodies, the hexagon is the measure of isometric drawings, and is easily constructed by drawing a circle with a pair of dividers and stepping off the distance to which they are opened for that circle, six times around the circle as a chord. Or the ordinary wooden triangle of 90°, 30°, & 60° gives the proper slopes directly.

I have drawn for you (drawing b^2) in isometric projection, a carpenters' bench 6 feet by 2, and in the hexagon accompanying it for a scale, I have divided up the foot into inches.[11]

I have drawn the same bench smaller with the other isometric view, to show you the choice you may have.

We might have chosen to show the back instead of the front; but in a carpenters' bench this would be foolish as the back is less interesting.

We might have chosen rather to show the bottom of the bench than the top. I never saw an isometric drawing so made, but there is no good reason why it should not be done if any thing were to be gained by it.

An isometric drawing is always ugly inasmuch as it looks like bad perspective, but it is useful.

If curves or complex forms occur in an isometric drawing, they can be put in by the method of the little squares.

If it is wished to make measurements out of the rectangular axes, a scale can be constructed for any angle by means of the method of the little squares or the little cubes.

The foreshortening of the isometric lines gives to them as compared with the original ones a length as .8164 to 1; but except in the case of an isometric drawing forming a part of some extended mechanical drawings, it is better to start the isometric lines at once to some simple scale, as if they were original lines.

The great advantage of isometric drawing is that in one single drawing it pictures the three most important faces of a rectangular thing (whereas an ordinary mechanical drawing shows but one,) and in a scale easily measured.

Drawing b²

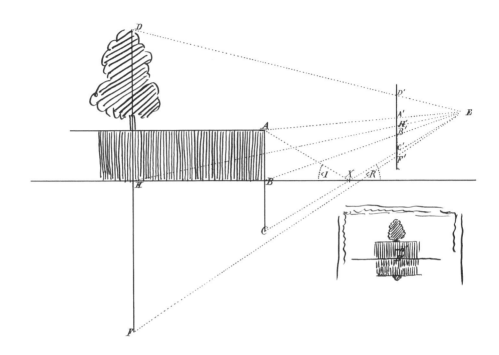

Drawing a¹

REFLECTIONS IN WATER.

A R G U M E N T .

Reflections in calm water. Those in agitated water. A schematic wave of very simple construction is formed & its reflections considered, which reflections being limits of those of real wave forms & always close to them, are a sufficient guide to the painter for pictorial purposes. Caustics are mentioned, and a law given for refraction in water.

THE CALM SURFACE of water reflects like a looking glass and we see reproduced upside down the images of the real objects. The law of such reflection is very simple. It is that the angle of reflection equals the angle of incidence.

The reflection of an upright object will, on the water's edge,[12] appear to go down as far below the surface of the water as the object reaches above that surface.

In drawing a[1] we have AB, the side of a wharf upright. Let E be the place of the eye of the spectator & $D'A'H'B'C'F'$ the plane of a picture.

The ray of light from A, the top of the wharf, which strikes the surface of the water at X, is the one which reflected at the angle of incidence reaches the eye, but the eye accustomed to light coming in straight lines does not account for the break at X but continues mentally the line EX to C & thinks to see there the reproduction of A. Angle I & Angle R being equal, the angle BXC must also be their equal, & BC is therefore equal to AB. In the same way FH is the same as DH.

Remember then in drawing reflections to use only vertical heights, that is see how high a point may be vertically above the surface & where this vertical pierces the plane of the water is the place to measure the depth of your reflection from.

The eye being above the surface of the water, the further a spot may be from the eye on the surface, the higher will be its place on the picture plane, & it is this which prevents absolute symmetry of the picture above with the picture below the water.

In drawing a[1] you see in the little picture I have made, the wharf & the tree & its trunk, but in the reflection you see only the wharf & the top of the tree; the wharf & its reflection being divided at B'; the tree & its reflection at H' further off.

It thus often happens that things are seen in the upper part that do not show

Drawing a²

below & vice versa. You have all doubtless noticed in boating towards evening, the strong relief of the reflections of near reeds against the sky, where above the water you cannot see at all the tops of the reeds because the landscape, being too much of the same tone with them, comes between them and the sky.

In drawing a² I show you that a post with its top coming towards you is in a picture longer in the water than above, whilst a post sloping the other way is longer above than below, but this you understand in seeing the drawing and remembering to measure only uprights.

When the surface of the water comes very close to you, the reflection diminishes, and you begin to see things under the surface.

This then disposing of reflections in calm water, we must examine reflections when the water has been thrown into waves.

Each wave being curved has an infinity of planes which could not all be examined separately; but some of these planes, from their marking limits, are more interesting than others, and we may completely simplify our study of waves by assuming for the present that they are made up of level planes and the tangent planes making the greatest departure from the level. Such simplified wave forms (see drawing a³) do not depart so very far from the real ones, needing only a little cutting off from the upper corners & a little filling up of the lower ones.

An upright post reflected in such waves would be seen on the level parts at the top & bottom of waves, of the same height or depth as the post itself from these levels. On the far sides of the waves, the sides sloping down & away from the spectator, the reflection would come closer to the feet of the spectator; on the near sides of the

Drawing a³

waves, the reflection of the top of the post would be further from the spectator than on the level parts; how much further the one & nearer the other depending on the slope of the waves, & being in fact the best possible measure of that slope.

Let us take for study (drawing a⁴) a post parallel with the plane of the picture, but sloping upwards to the right.

I have drawn a series of equidistant waves in perspective on this side of the post & have shaded for distinction the near side of each one from level to level leaving in white the far side of each from top level to bottom level.

Now the reflection of the top point A of the post will on the level parts reach down to A'' as far below the surface as A was above & a straight line drawn from A'' up to the water line of the post will represent the reflection of the post itself wherever the water happens to be level.

In like manner A' represents the reflection of the point A on the near side of the wave at its utmost slope, and a line drawn from A' to the water line of the post will be the reflection of the post wherever a wave has the greatest slope on the near side.

A''' represents on the greatest slope of the off side of a wave the top A of the post, & a line drawn from A''' to the water line of the post will coincide with the reflection of the post wherever a wave is at its greatest slope on the off side.

Drawing a⁴

We now have a sufficient number of points to draw our reflection of the post, & the rounding out of the corners of our schematic wave to more closely approximate to the real wave form will join the points of reflection of the post into a curve rather than a broken line & this curve which I have drawn for you I think you are all familiar with.

We may vary our waves as we choose, only taking care not to overstep the limits we set up as limits in our schematic wave, after a due consideration of the facts to be represented.

Much as the waves may vary, there is a certain likeness between them all.[13] One wave may be considerably larger than another one, but they are of such general size that 10 of them will differ very little from 10 others, and a hundred waves will be almost exactly the size of any other hundred at the same time & place.

It could never happen, even in a tolerably short space, that a wave twice as far from the eye as another should be twice as big, 4 times as far off 4 times the size, etc., so as to neutralize the great law of perspective; and if then the perspective is well constructed and there is a schematic construction of the wave close to the real form, you need have no fear of the accidental forms.

WE CALL ACCIDENT the result of complex reactions of unknown factors or of the numerous little neglected parts of factors, the principal parts only of which we may have been able to combine to deduce laws. Accidentals then are simply things beyond our ken. Greater knowledge reduces them, but only infinite knowledge could eliminate them.

You need not happily study for reflections those minor systems of waves always present with the big ones, riding over the big system without interference. You can indicate them by guess work, playfully or capriciously, the construction of your big system with its limits holding you in check. You may also guess at the horizontal or sideways variations induced by the waves coming slanting towards you instead of straight towards you.

THERE IS SO MUCH BEAUTY in reflections that it is generally well worth while to try to get them right. The post just given was very simple, & so were the wave forms. In reflecting a more complicated thing, it is well to have colored inks, one color for the level reflection, one for the long one, one for the short one, and to draw the three outlines: so that in painting any part of the wave, a reference to the three outlines at that place will show you just what part of your object is there to be reflected. You will notice that in each wave the part of it with the convexity upwards will give an upside down image, but that part with the concavity

Drawing a⁵

upwards will (if the wave is big enough) give the figure right side up. This you may easily see for yourself in the picture of the slanting post, noticing where the reflection slopes in a similar direction to the post, where in a reversed one.

Every one must have noticed on the sides of boats & wharves or rocks, when the sun is shining & the water in motion, never ending processions of bright points & lines, the lines twisting into various shapes, now going slowly or in a stately manner; then dancing & interweaving in violent fashion.

These points & lines are the reflections of the sun from the concave parts of the waves acting towards the sun as concave mirrors, focusing his rays now here, now there according to the shifting concavities.

These bright points & lines are called caustics, and may, by knowing the cause of them, the general character of the waves at the time, & direction of the sun, be sufficiently well imitated by guess work.

When you look down at the water tolerably near you, you can see into it, but the things going down into it appear to be bent, to change their direction just at the edge of the water.

This property is called refraction.

The law of refraction is that the sine of the angle of incidence to the normal of the surface at the point of incidence and the sine of the angle of refraction to the same normal bear a certain simple ratio to each other for any two substances. Between air & water the ratio is 4/3.

Let SO (drawing a⁵) be a ray of light at any angle striking through the air the surface of water AB at the point O. Draw the normal to the surface AB at the point O, the vertical CO. Draw a circle with the point of incidence as a centre & where OS intersects the circle as at D draw a line back to CO at right angles with CO & intersecting it at E. The line DE is the sine of the angle of incidence, of the

Drawing a⁶

Drawing a⁷

angle *COS*. Divide this sine of the angle of incidence into 4 equal parts and take 3 of these 4 parts & lay them off on *AB* from *O* towards *A* for a measure of the sine of refraction, & drop from the end of the third division a vertical, parallel with the normal & intersecting the circle at *R*. *RF* is then three fourths of *ED*, or the sine of the angle of refraction is $\frac{3}{4}$ths of the sine of the angle of incidence, and *OR* is the refraction in water of the incident ray *SO*.

Conversely if the light went the other way, the ray *RO* up through the water would be refracted in the air along the line *OS*, ratio 3/4.

A man looking from *S* through *O* would see the point *R* which would appear to be at *X*, as his instinct tells him wrongly in this case that light travels in a straight line.

A familiar experiment is to place a coin in an opaque bowl & to take back the head so far that the upper edge of the bowl just hides the coin. On pouring water into the bowl the coin becomes visible without moving the head forwards. Hence

water always appears more shallow to the eye than it is.

To demonstrate the apparent bend of a straight stick entering the water, let *LO* (drawing a⁶) be a ray of light travelling through the water & refracted in the air in the direction *ODS*, & entering the eye situated somewhere on a prolongation of this line *ODS*. Then to this eye the point *L* would seem to be at *K*. Now let *GIKLH* be the trace of a plane at right angles to the paper which contains the incident & refracted rays, and suppose a stick set at any angle in that plane & touching the point *L*.

If we revolve the drawing & the eye of the spectator about this axis *GIKLH* through an angle of 90° to lay the plane through *GIKLH* in the plane of the paper, we have (drawing a⁷) *L* for the lower end of the stick and *K* for its apparent depth to the eye situated as described.[14]

Drawing through *L* the stick at different angles we have its appearance *KMN*, *KQP*, *KVW*, and so forth.

Between the very near water where you see into it, & the farther water that you see only reflections from, there is a doubtful space where you see either the things in it by refraction, or the things out of it by reflection, according as you focus your eye for near or for far.

As water though such a good mirror yet does not reflect all its light regularly, there may be seen on it generally, even at its clearest, shadows cast from the objects between it & the sun.

SHADOWS

As in mechanical drawing a point may be so easily represented anywhere by reference to the 3 rectangular coordinate planes: two such points may be made by varying their places to give all possible directions to a straight line drawn through them. A line being drawn in the direction of the sun's rays, others parallel to this one from points in the objects in the drawing, will show the place of the shadows of such points and tracings may then be made of the shadow of the object [drawing a⁸].[15]

The mechanical draughtsman who is always ready to sacrifice the picturesque to the conventional to gain clearness & uniformity of treatment, supposes the light to come from left to right, from above downwards, from before to behind at such a degree of slope that it makes an angle of 45° in all the 3 planes of projection. In other words it traverses a cube from corner to corner.

The artist however does not of course confine himself to any direction.

Neither does he confine himself to sunlight whose rays are parallel, but may choose to show shadows falling from a candle as the source of light, the shadows in this case being probably much larger than the objects casting them.[16] Or the source of light may be as a window, larger than the object represented, and then the

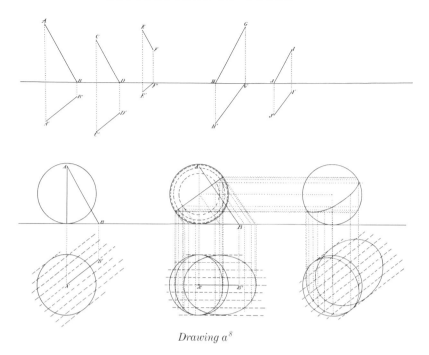

Drawing a⁸

shadow thrown by the objects will be less than the objects. Nor will the shadows in this last case be well defined, but a penumbra will extend on the wall behind, from where the side of the object begins to hide a little of the window, to where it hides the whole window when real shadow begins.

FRAMING THE PICTURE

THERE IS NO mathematical impossibility about making a picture far wider than the eye can see it at one time, but a very wide picture so made is very ugly.[17] I have seen a rule that a picture should not be wider in its diagonal than the picture is distant from the eye. I think this would be the very extreme limit of its greatness. The other limit would be where the picture becomes small enough to appear trifling. But it must be understood that the relation between the size of the objects drawn & the size of the drawing of these objects has to do with the eye's distance from them & from the picture & nothing to do with how much of the view you choose to intercept in the frame. The frame must be put on evenly with regard to the middle plane, but the horizon is so apparent usually that there is no necessity for putting that in the centre too. Indeed it generally looks less formal to do otherwise. A low, flat landscape or marine is often painted with the horizon below the middle, and a view from a high mountain is often painted with a high horizon.

The horizon may indeed be outside entirely of the picture or even out of the frame. For instance you might want to paint a little baby child playing on the floor.[18]

SCULPTURED RELIEF.

ARGUMENT.

A perspective in 3 dimensions. One more datum is required than in a picture perspective before commencing the construction: to wit, the depth of relief. Having all the data, a simple problem is chosen & solved and the law deduced by which we may make a scale on which to construct our relief.

A still simpler law may, under circumstances pointed out, so closely approximate its results to the truth, that under these circumstances it may be substituted for the true law.

The round falling table top placed in plane perspective before, is now drawn in a perspective of three dimensions, the manner of drawing being pointed out.[19]

RELIEF HOLDS A PLACE between a painting or drawing on a flat surface and a piece of full sculpture.

If a man looking into a hollow box $ABCD$ wished to make a relief of it, he would draw lines from the corners to his eye. (drawing c^1)[20]

Now any point on the line AC as a, a' or a'' may be made to represent in relief the point A & so on the BE line the representation may be made of the point B.

If the points are so chosen that the lines ab & cd are long, the relief is a deep one, alto-rilievo. If they are so chosen that the lines $a'b'$ & $c'd'$ are short, we have low relief, basso-rilievo. If the relief is brought near the eye, it is a small piece of sculpture; if carried farther off, it is larger just in proportion as it is taken away from the eye.

Let us, as in our simpler perspective, take some simple problem in hopes of discovering a law whose development may cover all cases of relief.

Let XY (drawing c^2) represent the horizon plane, and 0, 1, 2, 3, 4, 5, . . . ∞, represent the level floor, the numbers marking feet forwards of the eye. Let GH represent a vertical picture plane placed at such distance from the eye as to give in the representation of an object in Nature the size determined upon.

This is our old perspective problem, & the picture of the feet growing smaller and smaller as they recede, there is room on the picture plane for the representation of infinite distance up to the horizon.

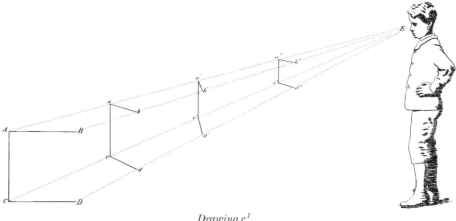

Drawing c¹

If the picture plane be tilted as *AB*, & considered as a picture of the floor, its feet marks would indicate in a relief the proper depth for the things resting on corresponding feet marks in nature, and vertical lines remaining vertical, the picture of square feet upon the tilting floor gives us a perspective scale in three dimensions almost as simple as that for a flat picture.

As in painting we arbitrarily fixed the distance from the eye of our picture to accord with our wish as to its size, we must in relief fix not only the distance from the eye to control according to our desire the size, but also we must determine arbitrarily the slope of our floor line. If we wish our relief to be very flat as in a coin, we choose a line as *FE* (drawing c²) nearly perpendicular. If we wish high relief, we slope our floor well in, as the line *CD*.

So we are free to go mathematically with our floor in establishing our scale of relief anywhere between the vertical & the real level floor, or even beyond the level making things deeper than nature, but this would be foolish.

Indeed, a relief should, I think, seldom be fuller than $\frac{1}{2}$ nature; for if too full, it ceases to have a mechanical reason for being a relief, but had better be full sculpture.

The best examples of relief sculpture are the ancient Greek.

Where the subject of relief becomes complicated, as in the gates of Ghiberti at Florence, and distant landscape architecture and other accessories are shown, the simple plan above is departed from. The near figures which are of the greatest interest are in full or nearly full relief, and the distant parts have a very flat relief so that the level floor line if used to give us our scale would no longer be chosen a straight line, but a curved one as *IJ*.

A great disadvantage in such relief as Ghiberti's is that when viewed in the light most favorable for showing the form, the near figures throw shadows on the distant landscape and other parts.

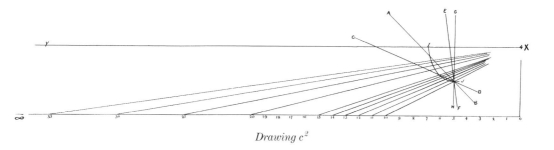

Drawing c²

This change of scale is a departure from the simplicity of the Greek frieze. The Greeks chose subjects for their reliefs exactly suited to their means of expression.[21]

A scale having been chosen will have to be modified anyhow here and there a little for mechanical exigencies. The toughness, strength, brittleness & other qualities of the stone, or wood or bronze or other material composing the relief, will influence the support necessary to the different parts and should indeed be factors in the conception of the work.

But the departure from the scale should never, in any place, be more than just necessary, and what departure is made, should be by easy gradients and the most gentle curves. I think that nine-tenths of the people looking at the frieze of the Parthenon would remember the figures as put upon a plane surface, which is not the case.[22]

If architecture or things requiring long straight lines are introduced in a shifting scale like Ghiberti's, it is well to straighten the curve of the scale wherever these straight lines are to appear, so that they may not be curved to a spectator who may move his eye ever so little from the true point of sight.[23]

When the spectator is moderately far off compared with the depth of his subject, & the subject is of no great extent, as in modelling a head for instance, the slight perspective change induced by the one side of the head being a little further off than the other, may be neglected and a simpler scale substituted.[24]

Let the head be modelled every where $\frac{1}{2}$ as full, $\frac{1}{4}$th as full, $\frac{1}{8}$th as full, or $\frac{1}{n}$th as full in every part as Nature.

Modern sculptors do not generally understand the beauty of relief, & I have often seen an ear in a profile head as deep as all the rest of the head.

LET US WORK OUT a problem. We will take the falling top table we drew before in simple perspective, and we will keep up all the old conditions. We will as the new condition make a relief of such a depth that 18 feet should mark the limit of $\frac{1}{2}$ the depth of Nature, so that anything nearer than 18 feet would be more than $\frac{1}{2}$ as deep as Nature, but anything beyond 18 feet would be less than $\frac{1}{2}$ as deep as Nature.

Drawing c³

Drawing c³ will then represent the conditions. Let E be the place of the eye, & 18, 19, 20 etc. to infinity will be feet along the floor measured forwards of the eye.

From the 18 foot floor line draw a new floor line tilting up & intersecting the horizon 18 feet further from the eye, or 36 feet forwards, in order to give a $\frac{1}{2}$ depth at 18. The new floor line will be the scale for the relief. The horizontal and vertical projections of this scale will be the scales most convenient to work by. A pair of straight battens nailed to the sides of the plaster or wood on which the relief is modelled, a straight edge to lay across these battens, and an inch rule to measure depth with, will be most useful to copy from the drawing to the plaster, clay, or wax.

In the above diagram, as our relief was to be 12 times smaller than nature, CD represents the place of 18 feet off & FD represents the tilted floor of the base relief.

Now let us make our scale for a ground plan, the projection on a level surface of the tilted floor, such as XVIII ... XXIV ... ∞ would represent (drawing c³).

Draw (drawing c⁴) a horizontal line for the 18 foot line & a vertical line for the middle plane & mark distances on the 18 foot line 1 inch apart (as our relief is to be 12 times as small as the real at 18 feet).

The point of sight being on the horizon where the floor intersects it is 18 feet forward of the 18 foot plane, or in relief $\frac{1}{12}$th of 18 feet or 18 inches. Draw lines then from the feet marks converging to a point 18 inches forward of the 18 foot line.

We then get our scale of feet forwards by a diagonal to a vanishing point, but remember now that the line vanishes at F (drawing c³) not at C as in flat perspective. A line sloping at an angle of 45° would vanish then at a point 18 inches forward of the 18 foot line or where the floor pierces the horizon or 36 inches forward of the eye & 36 inches to the right.

A line such as I have chosen (not to run off of my drawing board & paper) is one sloping in Nature 1 to the right for every 2 forwards. Such a line must vanish in the drawing 18 inches to the right on the horizon. Drawing it from the 0 & 18 intersection, we get by the first intersection with the line 1 foot to the right, the place of the 20 foot line; the second intersection gives us the 22 foot line & so on &

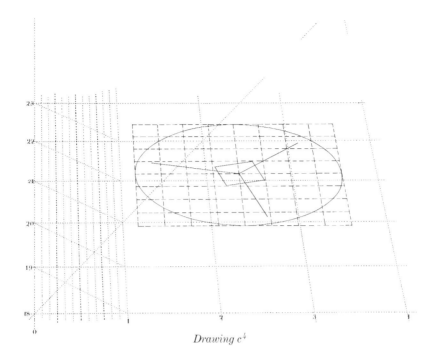

Drawing c⁴

the intermediate feet are found as in the perspective on a plane. A foot should then be divided into inches & diagonals drawn.

The original ground plan drawing of the table [see drawing 12] can now be transferred to the new ground plan of relief & you will notice how it has shortened a little more than double from before backwards.

The end elevation is best made by giving the floor line the predetermined slope & laying off on a horizontal line *ab* the distances forward of the eye by feet & inches taken from the relief ground plan.

All difficulty is now at an end, and a side elevation or end elevation may be made, or you may make both of them as I have made for illustration, drawing [c⁵ and c⁴ or c⁵ variant],[25] or you may make neither of them, working direct in the plaster by means of your scales, only measuring from your battens.

An inspection of these drawings & a comparison with the plane perspective one of the same table [see drawing 13] will show most clearly what I said about relief being intermediate between drawing & sculpture. In the side elevation, you will notice the table top is longer than in the plane perspective because of its distance beyond the plane of 18 feet or its representative $1\frac{1}{2}$ feet. You will also notice it is much narrower, because the eye being above the table, the depth of relief allows a greater angle to be subtended to the eye. The depth though is not so great as in the

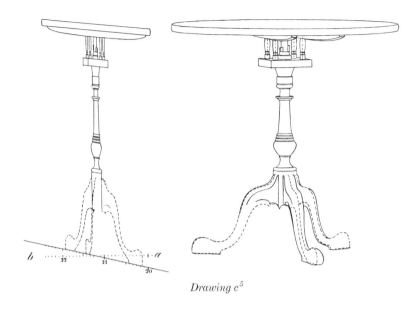

Drawing c^5

real table top but the top tilts in the relief to make up for the want of real depth, and so on.

Remember that the real table, any relief of the table high or low relief, any plane picture of the table should all cover each other exactly to the eye of the spectator.

F O C U S　O F　T H E　E Y E

Experiment. If you hold up your two forefingers in front of your eye, one at arm's length and the other half a bar, the eye cannot see them both sharp at the same time. If you sharpen your eye on the near one the distant one blurs, but if you look sharp at the far one, then the near one blurs.

Now if you should attempt to paint a picture of these two fingers, you must choose to look at one or the other finger & give to it only the sharpness. The attempt to paint them both sharp would make the far one look, if properly proportioned, like a finger half the size it ought to be or the near one double the size.

The character of depth is incompatible with that of sharpness, especially as you go out sideways from the point of sight, & one or the other characteristic must be sacrificed in a picture. If your picture is simply to convey an impression you will probably choose to give the depth, but if you were drawing a sloping away bridge for an engineer you would sacrifice the feeling of depth (except what comes from correct perspective) entirely to a conscientious reproduction of all the constructive details, whether far or near. Between these cases as extremes you will make your

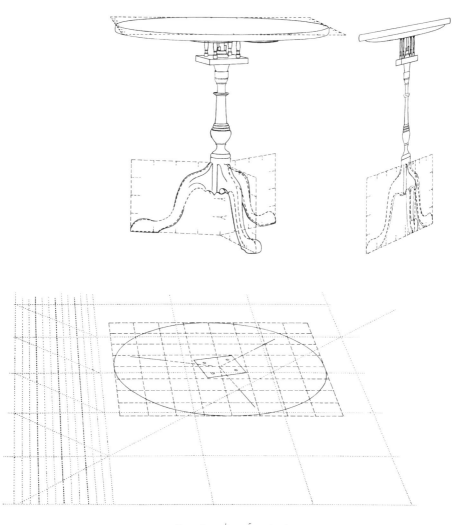

Drawing c⁴ or c⁵ variant

picture as it most strongly impresses you with its character & as you want to impress by it the spectators of your picture.

If you wish to increase in your eye the entire sharpness of a group of objects you must go further away back from them so that the distance from one to the other of them may be very small in comparison with the distance from the eye to one of them.

A strong light like sunlight also sharpens objects in different planes at the same time by shutting greatly the pupil of the eye.

¹ Written across this paragraph of the manuscript, in a hand other than Eakins's, are the words, "This does not seem to me true, it is badly stated or not in place."

² Eakins revised the lettering on drawing 2 in pencil but did not change the text. We have corrected the drawing to follow his final instructions and adjusted the lettering in the text accordingly. Similar corrections have been made to drawing 4. For the unaltered appearance of both drawings, see Kathleen A. Foster, *Thomas Eakins Rediscovered* (New Haven: Yale University Press, 1997), p. 333, cats. 95, 96.

³ In this drawing, the viewer stands correctly in front of an enlarged version of Eakins's own 1874 composition *Starting Out after Rail* (Museum of Fine Arts, Boston), similar to fig. 5. See Darrel Sewell, ed., *Thomas Eakins* (Philadelphia: Philadelphia Museum of Art, 2001), p. 51, plate 12.

⁴ Revised from "the authors" in earlier drafts. "We must make our pictures to suit this most natural way of looking at them," he asserted in his first draft, and "save the students [from] the oblique perspective of the authors" (Charles Bregler's Thomas Eakins Collection, Pennsylvania Academy of the Fine Arts Archives, Philadelphia). Like his observation in Chapter I that a perspective drawing can be cast on any surface, no matter how tilted or warped, this comment suggests familiarity with more complex and arcane "authors" and treatises (see Werbel, this volume), and forecasts his later section on sculptured relief (see Chapter VII below).

⁵ Eakins has labeled two lines in the drawing: *eg* = "Perspective of a line sloping 1 sideways to 4 forwards and level vanishing on horizon 6 inches to right of centre"; *eh* = "Perspective of line sloping 45° or 1 to 1 vanishing on horizon of the picture at 2 ft. to the right of centre."

⁶ Eakins refers here to drawing 4, although it does not illustrate this "little device." This stray reference may indicate an earlier list or order of figures.

⁷ Drawings 12 and 13 show the table 2 feet 5 inches to the right of the center line, although the manuscript calls for placement 1 foot 5 inches to the right. Two earlier versions of this illustration show the first placement; see Foster, *Thomas Eakins Rediscovered*, pp. 338–39, cats. 107, 108. Eakins made the adjustment, which necessitated relabeling drawing 12 and completely redrafting drawing 13, but he never changed the text accordingly, as we have done here.

⁸ The sketch of the plan of this staircase in Eakins's first draft is labeled "Stairway in Brooklyn Library." He notes that the rail is 32 inches high.

⁹ Eakins referred to the object depicted as a "tin tea pot" in his first draft, then as a "common tin coffee pot." The illustrations at PAFA were catalogued with the first title, though more correctly the form is a coffee pot. See Foster, *Thomas Eakins Rediscovered*, pp. 342–43, cats. 114, 115.

¹⁰ As an illustration, see fig. 5 or Eakins's *Starting Out after Rail* (see note 3 above).

¹¹ From the first draft: "This drawing is made 1 to 1 foot before tilting. Its isometric scale is 1:12. When the isometric drawing stands alone, that is, it is not part of an extended mechanical drawing,

it is best to make the isometric limit themselves to a scale bearing a simple relation to the ordinary measure, say $\frac{1}{2}, \frac{1}{4}, \frac{1}{6}, \frac{1}{12}$, or the like" (Bregler Collection, PAFA).

[12] Phrase inserted from a variant draft in the Eakins Archive, Department of American Art, Philadelphia Museum of Art (hereafter PMA).

[13] Phrase inserted from variant draft (PMA).

[14] This sentence was changed slightly for sense. Eakins's original reads: "Revolving about this axis *GIKLH* the drawing & the eye of the spectator through an angle of 90° to lay the plane through *GIKLH* in the plane of the paper we have (drawing a[7]) *L* for the lower end of the stick and *K* for its apparent depth to the eye situated as described."

[15] In the first draft, Eakins added: "The sun's rays are practically parallel" (Bregler Collection, PAFA). A diagram sketched next to this text corresponds to drawing a[8]. See Foster, *Thomas Eakins Rediscovered*, p. 352, cat. 140. Because Eakins never developed this text any further to explain the purposes of this illustration in detail, it can only be understood as a demonstration of the shadows cast by a sphere.

[16] The first draft reads: "[Any] other source which if smaller than the objects will throw shadows which become wider than the objects" (Bregler Collection, PAFA).

[17] This section appears in only one draft (PMA), following an incomplete variant text of the section on reflections and a sketch of the plan of the spiral staircase studied in drawing 14. Eakins evidently added this text to the lower part of the sheet as a later, unrelated topic, and its correct placement in the manuscript remains unclear.

[18] The final three sentences are from a page in the Bregler Collection, PAFA. The manuscript is by no means clear, and I have guessed on a few words. Below the text is a sketch reminiscent of Eakins's painting *Baby at Play* of 1876 (National Gallery of Art, Washington, D.C.). See Sewell, ed., *Thomas Eakins*, p. 57, plate 18.

[19] At the top of the first sheet of this section is inscribed "Thomas Eakins./I believe this paper to be entirely original. T.E." (see fig. 2). The drawings for this section are numbered $c^1 - c^{10}$.

[20] A slightly smaller variant of this drawing is in the collection of the Hirshhorn Museum, Washington, D.C. The relief forms are shown in three dimensions, to make clearer the compression of the relief as it comes closer to the eye. The drawing reproduced here (Bregler Collection, PAFA) corresponds, however, to the labels given in the text and (unlike the Hirshhorn drawing) is annotated "C drawing 1." See Phyllis D. Rosenzweig, *The Thomas Eakins Collection of the Hirshhorn Museum and Sculpture Garden* (Washington, D.C.: Smithsonian Institution Press, 1977), p. 117, cat. 57; Foster, *Thomas Eakins Rediscovered*, p. 349, cat. 132.

[21] Variant text in the incomplete early draft (PMA) reads: "This change of scale is a departure from the simplicity of the Greek frieze, that is made necessary by the greater complication of the subject. The simple processions of the Greeks viewed in profile or nearly so are exactly suited to reproduction in relief sculpture."

[22] Variant text in the incomplete early draft (PMA) reads: "Nine tenths of the people who have seen casts of the frieze of the Parthenon would say the figures are backed by a plane surface, so gentle are its numerous curves which are instantly seen on looking endways or pulling in a skimming light."

[23] Variant text in the incomplete early draft (PMA) reads: "When a curving changeable scale like Ghiberti's is made use of, it is well to straighten the parts of the curve where any architectural work

or other straight lines are represented, as it would be awkward to have straight lines represented by curved ones that will look straight only from exactly the right spot, and look curved the moment that the eye departs ever so little from its perspective station."

[24] Variant text in the incomplete early draft (PMA) reads: "When the spectator is moderately far off compared with the depth of the subject, say as represented on a coin, it will not be necessary to consider strictly the perspective scale getting smaller as you step back but the thing may be modelled as if simply twice as flat as the original or 4 times as flat or 8 times or a times as flat as the original."

[25] This illustration is not numbered in the draft. The drawing reproduced here (Bregler Collection, PAFA, 1985.68.3.20), labeled "c^5," illustrates the points in Eakins's text, but it shows the relief from a lower eye level than the one used in the earlier illustrations in this series. Another drawing, unlabeled (reproduced here as c^4 or c^5 variant), recapitulates the exercise with a steeper slope to the floor of the relief and from a higher vantage, exactly like the final drawing 13 (reproduced above). Eakins may have intended the variant drawing as a combination and revision of drawings c^4 and c^5, but then abandoned it when the drawing book project stalled. See Foster, *Thomas Eakins Rediscovered*, pp. 352–52, cats. 137, 138.

APPENDICES

Notes on the Construction of a Camera

In February of 1883, Eadweard Muybridge lectured at the Pennsylvania Academy of the Fine Arts on his innovative photographs of humans and animals in motion. Before the end of that year, he was invited by the University of Pennsylvania to return to Philadelphia to work under the supervision of a commission of interested medical doctors and engineers. Thomas Eakins, who had followed Muybridge's work on animal locomotion since 1878, was asked to serve on the commission, which mobilized in the spring of 1884. In June of that year, Eakins's account book records expenses for "tools used in making quick shutter for Marey & Muybridge photos,"[1] indicating that he was working on his own camera experiments alongside Muybridge. Critical of Muybridge's system because it failed to record precisely the time between exposures, Eakins developed his own mechanism based on the camera of the French physiologist Etienne-Jules Marey. The original Marey camera recorded multiple, overlapping images on the same plate; Eakins's variant on the Marey system held a rotating, hexagonal plate that kept each new exposure distinct. To monitor the exposure times and intervals, he attached to the camera a "chronograph" invented by his friend and colleague on the commission, Professor William D. Marks. Their electrical apparatus, seen in Eakins's portrait of Marks from 1886 (fig. 17), failed in August 1884 and was rebuilt; then problems arose with light fogging of the plates from multiple exposures. Eakins built an improved camera and a special shed at the university in the fall of 1884 to deal with these problems, but only a few photos were taken before it became too cold for the nude models to work outdoors. The more than fifty surviving plates from the project were made in this shed the following spring and summer, when Eakins and his models and student assistants, Thomas Anshutz and John Laurie Wallace, took turns in front of and behind the camera. Most of their images used the simpler Marey camera with a stationary negative (fig. 18), but two survive on the hexagonal glass plates that rotated behind the lens (fig. 19), which Eakins describes in these notes.

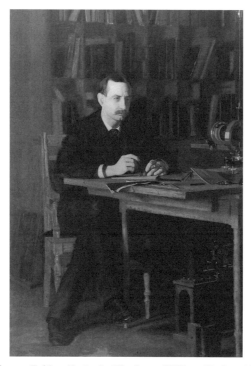

Fig. 17. Thomas Eakins, *Portrait of Professor William Marks*, 1886. Oil on canvas, 76³/₈ x 54¹/₈ inches (194 x 137.5 cm). Washington University Gallery of Art, St. Louis. University purchase, Yeatman Fund, 1936, WU 2944.

Eakins planned to write about his work in the commission's report, which fol-lowed Muybridge's own book, Animal Locomotion *(1888), but like the drawing man-ual, his text seems to have been left unfinished in the aftermath of his departure from the Academy in 1886. Ultimately, his part in the project was summarized by his friend Marks, who used one of Eakins's plates (fig. 19) to illustrate the report and noted with regret that "Professor Eakins's admirable work is not yet suffi-ciently complete for publication as a whole."² The following notes may be a draft for that report.³*

The manuscript is heavily revised, with many cross-outs, inserts above and below the line, false starts, illegible handwriting, and a confusing simultaneity of options. I have edited it to correct odd spellings, regularize verbs, delete stray frag-ments, and insert punctuation, in order to capture the sense and forward motion of the text. Some alternate phrasings have been given in italics inside brackets when they help clarify the meaning. Despite these efforts, certain passages remain cryp-tic. Although illegible and incoherent in spots, this text offers insight into Eakins's

Fig. 18. Thomas Eakins, *A Man Walking, Full Face*, 1885. Twenty-one exposures on a revolving Marey-wheel dry plate negative, $10^{3}/_{16}$ x 10 inches (27.4 x 25.4 cm). From the Historical and Interpretive Collections of The Franklin Institute, Inc., Philadelphia.

talent for mechanical engineering and his search for scientific precision. As the only extant description of his own apparatus, put together with rubber bands and batteries, it serves as a snapshot of a heady moment when amateur experimentation was pressing forward the frontiers of photographic technology.

A CRANK TURNED by hand moves communicates to the discs [*gives through a belt*] from a large to a small pulley the requisite speed.

Between the discs & the lens is wedged an electric shutter. The discs revolving & the object set in motion, the observer with his fingers on the key board presses the first button when he wishes the impressions to begin [*photographic image to commence*] & the second button when he wishes them to end. Pressing the first button breaks contact of an electric circuit that holds against the force of a rubber spring the armature of the electric magnet controlling the trigger, which releases in the shutter a slide that covered the lens. The second button on the key board releases another opaque slide in the shutter which, having been held in place above the lens, now comes down in front of it.

The shutter was constructed to move very rapidly. The slides are little squares of silk waterproof kept stretched by pieces of silk-wrapped quill attached

Fig. 19. Thomas Eakins, *Boy Jumping Horizontally*, 1885. Gelatin silver print, 3^{11}/$_{16}$ x 4^{13}/$_{16}$ inches (9.4 x 12.2 cm). Philadelphia Museum of Art. Gift of Charles Bregler, 1977-171-5.

to the corners. These quills slide vertically [*up and down*] very loosely[?] on brass rods and the slides are pulled down by india rubber bands which reach down to the floor. The bands are the ordinary little gum bands looped together end to end. The reason of their length is as follows. The friction being overcome, rapidity is got from length not thickness of the spring. For instance, two gum bands side by side would not travel faster than one if stretched & let go, but if looped end to end, the speed of the one adds itself to the speed of the other. A piece of cat gut arrests the action of the spring without drawing tight the adjusted strings which pull the slides. The closed circuit was used that no time should be lost by the magnet reaching for the armature and because less battery power is required in the closed circuit.

As no ordinary background can be made perfectly dark and as the whole background is repeated at each image, unless precautions are taken the repeated small light of the background finally fogs figures. It was on this account that the ground was so carefully gone over.

In the camera used [*by Mr. Eakins*][4] in the present investigation a new precaution was taken. A moving diaphragm was used connected with a peep sight above the camera. An assistant having adjusted the diaphragm somewhat larger than the object, & placed his eye to the hind sight, followed the object photographed keeping

it between the two front sights, the hind sight being at a distance from the front [first?] sight equal the conjugate focus of the lens.

The plate itself also can be slid right & left by a bar in case several successive poses may be executed in the same place and their images wished for on one plate.

To increase the range of the instrument a second camera was devised for investigating the class of movement in one place, as of a man throwing a ball, where on the Marey camera the images would superimpose [fig. 18].

The second camera has an axle through it carrying a plate around which turns [*parallel with the disks*] by pulley connected with belting with the axle on which the crank is that moves the disks. Between the [illegible] & a pair of friction wheels allows such an adjustment of motion from the discs to the plate that the images may be made to just clear one another.

The ground glass is set true by adjusting screws & the lens is focused & then a 10 x 12 [inch] or smaller plate cut to an octagon is held sprung up against the adjusting screws. The distance apart of the images (in degrees) being determined, and the stylus connected with an electro magnet in circuit with the current, counting the exposures marks on the face of a [illegible] disc on the rear end of the axle turning the plate. A diaphragm was also arranged in front of this plate having[?] a slight horizontal movement & governed by a peep sight.

For recording the times & duration of exposure a chronograph was used which had been designed by Prof. Marks for the Franklin Institute. An electric current, a tuning fork for armature of our electro magnet, making and breaking circuit, another electro magnet in the same circuit with a stylus dotting on a smoked paper [*on a cylinder*] a series of dots $\frac{1}{100}$ of a second apart, furnished the regular comparison intervals. Alongside of this last electro magnet a similar one recorded the exposures.

The horizontal cylinder on which the paper was stretched & smoked could be turned by hand or clock work & the magnets were on a carriage which travelled slowly from left to right in front of the cylinder by means of a screw as in the slide rest of an engine lathe. The hundredths of a second then marked a dotted helix around the cylinder & the exposures are shown by short lines adjacent to the dots as the styluses of the two magnets are close together & the paper cut off, the helix becomes a straight line.

The means of establishing the circuit which marks the openings or exposures is as follows. An interrupted disc of brass & india rubber is fixed on the axis of the discs & turned that the brass may correspond to the openings & there clamped. A spring with platinum contact point pressing against it capable of movement in two slots at right angles with each other is also adjusted in place and according to the number of openings & brasses.

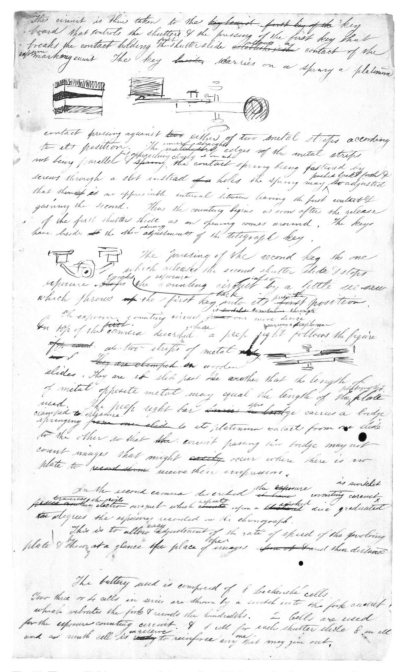

Fig. 20. Thomas Eakins, manuscript page from "Notes on the Construction of a Camera," showing sketches of the key mechanism. Philadelphia Museum of Art. Gift of Mrs. Ruth Strouse in memory of her father, Joseph Katz, 1963-198-103.

The circuit is then taken to the key board that controls the shutter & the pressing of the first key that breaks the contact holding the first shutter slide allows a contact of the exposure marking circuit. The key carries on a spring a platinum contact pressing against either of two metal strips according to its position. The inner straight edges of the metal strips not being parallel but approaching closely at one end, [and] the contact spring being fastened by screws through a slot instead of holes, the spring may be pushed back & forth & so adjusted that there is no appreciable interval between leaving the first contact & gaining the second. Thus the counting begins as soon after the release of the first shutter slide as an opening comes around. The keys have besides the other ordinary adjustments of the telegraph key [fig. 20].

The pressing of the second key, the one which releases the second shutter slide & stops [the] exposure, breaks the exposure counting circuit also by a little see saw which throws the first key back into its first position.

The exposure counting circuit is one more device. On top of the camera described, where a peep sight [illegible] a diaphragm follows the figure, are two strips of metal on wooden slides. They are so slid past by [one] another that the length of metal opposite metal may equal the length of the photographic plate used. The peep sight bar carries a bridge, clamped at pleasure, springing its platinum contacts from one slide to the other so that the circuit passing the bridge may not count images that might occur where there is no plate to receive their impressions.

In the second camera described the exposure counting circuit [*is switched/ traverses the coils*] passes another electro magnet which repeats upon a smoked disc graduated [in?] degrees the exposures recorded on the chronograph.

This is to allow easy adjustment of the rate of speed of the revolving plate & by showing at a glance the place of the images and their distance.

The battery used is composed of 8 Leclanché cells.[5] Two, three, or 4 cells in a series are thrown by a switch into the fork circuit which vibrates the fork & records the hundredths. 2 cells are used for the exposure counting circuit, & 1 cell for each shutter slide, 8 in all, and a ninth cell is in reserve to reinforce any one that may give out.

Other things out of consideration, it is better to increase the speed of aperture opening than to narrow the opening because the lens is doing its best work when entirely uncovered & its worst while but a fraction of the lens is exposed. A long opening passing rapidly reduces the ratio of the poor period of work to the good period work of the lens.[6]

NOTES

[1] From Eakins's account book in the collection of Mr. Daniel W. Dietrich II, cited in Gordon Hendricks, *The Photographs of Thomas Eakins* (New York: Grossman, 1972), pp. 6–8. On the Muybridge project, see Lloyd Goodrich, *Thomas Eakins* (Cambridge: Harvard University Press for the National Gallery of Art, 1982), vol. 1, pp. 268–78.

[2] W. D. Marks, "The Mechanism of Instantaneous Photography," in *Animal Locomotion: The Muybridge Work at the University of Pennsylvania—The Method and the Result* (Philadelphia: J. B. Lippincott, 1888), p. 13, quoted in Goodrich, *Thomas Eakins*, vol. 1, p. 277.

[3] Eakins did not give this manuscript a title. Charles Bregler's note, included with the papers when he sold them in 1944, called it "Notes on construction of a Camera with which he made the action photographs."

[4] This phrase is crossed out in the manuscript. The presence and subsequent deletion of his own name indicates that Eakins intended this text as a formal draft for publication.

[5] A carbon-zinc cell battery patented in 1866 by the French engineer Georges Leclanché.

[6] Below this last paragraph is a pencil outline, to the scale of the painting, of the reclining figure in Eakins's *Swimming* of 1884–85 (Amon Carter Museum, Forth Worth, Texas). See Sewell, ed., *Thomas Eakins*, p. 191, plate 149.

Notes on the Differential Action of Certain

Muscles Passing More Than One Joint

EDITOR'S NOTE.

*Eakins became interested in the anatomy of the horse in the late 1870s, when the publication of Eadweard Muybridge's motion photographs and his own project painting Fairman Rogers's four-in-hand coach (*A May Morning in the Park *of 1879; Philadelphia Museum of Art) launched a personal study of equine locomotion. In the course of dissection sessions with his students at the Academy, Eakins discovered that the conventional wisdom given in the standard text by the French veterinarian Auguste Chauveau (1827–1917),* Traité d'anatomie comparée des animaux domestiques *(3d ed.; Paris: J.-B. Ballière, 1879), failed to account for the actual system of ligaments, tendons, and muscles that keeps a horse standing. In 1884–85, while working at the University of Pennsylvania in a special shed built for motion photography, Eakins photographed his students with a dissected horse leg, demonstrating that the skeleton could still bear weight even after all the muscles had been removed (fig. 21). Ten years later, on May 1, 1894, Eakins presented his research and its conclusions to the members of the Academy of Natural Sciences in Philadelphia. His paper, "The Differential Action of Certain Muscles Passing More Than One Joint," which was published in the* Proceedings of the Academy of Natural Sciences *later that year,[1] demonstrated that certain muscles in the leg worked simultaneously, not in alternation. The six original pen-and-ink illustrations Eakins made for this article were found in the collection of his student, Charles Bregler, along with prints, glass negatives, and four glass lantern slides that may have been used for his lecture.[2]*

The manuscript of the published paper has not survived. These notes are briefer and rougher than the final paper and are organized differently; the rhetorical questions and colloquial phrasing indicate that it may have been the first draft of the lecture presentation made at the Academy. Not all of the quota-

tions from Chauveau included here were cited in his final text, and the references to his use of a camera invented by "Prof. [Etienne-Jules] Marey of Paris" were also deleted.

Chauveau p. 234. Pour determiner le rôle ou les usages des muscles il suffit de connaître leurs insertions et le mode d'articulation des os sur lesquels ils s'attachent.

The general notion I think that any beginner would get from reading any good standard work on myology would be that there is a tolerably simple division of the muscles into flexors & extensors & that of all the muscles, half of them are in action at any one time while the rest are idly waiting their turn. Any muscle going from one bone to another passing the angle would flex the joint if inside, extend it if outside.

Soon he would read of a class of muscles not quite so simple: those that pass over two joints, perhaps inside of one outside of another. But they are treated in almost the same simple manner. The usage of this muscle, says the book, is to extend the one joint and flex the other.

Les attaches ou insertions des muscles sont sans contredit la partie la plus importante de leur histoire, car les attaches d'un muscle étant données, il est facile en général, de determiner l'étendue, la direction, la forme et les usages de ce muscle.[3]

Duchenne in later times looked much more carefully into synergy of the different muscles.[4] What muscle must hold fast that another one may find a point of support & so on from one end of the body to the other.

Prof. Marey of Paris has introduced a new instrument of research.[5]

I have discovered[6]

But if we should examine a little less superficially one of this second class of muscles we should soon inquire, does it flex the one joint faster than it extends the other, or both at the same rate? Why does it flex one faster than it extends the other? Does it, during its whole movement, continue to flex one as much faster than it extends the other as at first, or does the ratio of the two movements constantly change and why; and in what proportion does it change & why? It suffices, say[s] Chauveau, to understand the uses of a muscle if you know its insertions and the mode of articulation.

Who knows the mode of articulation? What curious curves, unsymmetrical in all three directions, of the nth degree.

When a man makes a machine he moves a straight line along a straight line or a circle in a circle. His joints are mostly round holes with round pins in them. His

Fig. 21. Thomas Eakins, *Differential Action Study: Man on Ladder, Leaning on Horse's Stripped Foreleg*, 1885. Gelatin silver print, sheet 5 1/8 x 9 9/16 inches (13 x 16.7 cm). Philadelphia Museum of Art. Gift of Charles Bregler, 1977-171-20.

sublime effort is the surface of a cog wheel. Yet how different even this from [the] surfaces of Nature's joints.

If then these uses & movements must be so complicated, can we ever hope to understand them. Not very well, and yet roughly we may know something of them if we begin our study at the other end.

What other end? The thing to be done by [*the function of*] a machine is more simple than the machine itself.

[*Can we know the required movement &*] And if we draw a required movement we may perhaps be able synthetically [to] deduce the kind of machinery necessary to effect it. Thanks to the admirable photography inventions of Prof. Marey we can record movement, get upon paper a series of pictures which joined will give us the trajectories of movement.

I say then if we can but know what is required & then try synthetically to construct even a poor machine which attempts to fulfill the requirement we shall come to a much better understanding than if we merely examined the machine itself & tried to analyze [it] [*& it is for this*] that I have my Marey machines.

I had long ago noticed in dissecting that horses legs [*that a machine* (illegible)] that if you moved one of the parts of the hind leg, the hoof for instance, that every

other bone in the leg & even too the pelvis itself moved also. In following up this I found many interesting phenomena.

Among others we noticed that the leg, if the hoof was put in its proper position, that the leg supported itself. Moreover it supported the weight of many boys on it.

Then we began to cut away different parts until nothing was left but what we found necessary to make it stand.

We had by that time cut away all the muscle and thus discovered that an automatic arrangement independent of muscular exertion prevents the hind leg from doubling up & letting the animal down. Yet the automatic arrangement allows of a back & forth movement with a slight rise & fall which we had often looked at & considered, but are now able to record with our machine.

The horse takes a step with his hind leg, plants its hoof on the ground & if the hoof lies flat he may fearlessly put his weight upon the leg without any possibility of its giving away under him. It is as stiff [*resistant*] as if [*of one pc.*] solid. Yet the top carrying the boy does not move up in a circular arc, as it would be bound to if the leg was of one solid piece, which would enormously waste power, but in a curve with a gentle rise.

The most interesting part perhaps of the machinery of like kind is a cord running from the femur to metatarsus the tendenous posterior[?] flexor of the metatarsus or anterior leg muscle. It is as Chauveau suggests the peroneus tertius of man.

This tendon says Chauveau 357 has the curious property of flexing the leg by a purely mechanical action, when the bones above are flexed. It is then a conducting cord charged with the duty of [illegible]. This we see beautifully in the record herein.

They have attributed to it another use says Chauveau, that of opposing itself passively to the flexion of the femur while standing & serving as an aid to the muscular forces which hold up the body. "This is wrong according to our notion," says Chauveau "in order to fulfill this function the joint would have to be held fixed by the contraction of the extensor muscles.["?] Now these muscles are really the gastrocnemii of the leg which take their origin behind the femur & which tend to flex this bone on the tibia, that is to say, to make the movement they are supposed to hinder. Now our experiment shown on plate X proves these indefinite people w[ere] right by guess, for the dead horse leg stands & we had cut entirely away the gastrocnemius & there is nothing to hold the femur tibial joint except this cord. "Besides" says Chauveau "experiment proves we are right. The cutting of this cord in the living animal does not trouble his exterior appearance neither on his four legs nor 3 legs.["]

Now can any one believe so powerful a cord to have been put there for nothing but to raise the leg. We can not deny that the horse can stand & [illegible] walk without this cord, but deprived of his automatic support & compelled to rely on muscular force he would be very weary and break down.[7] [*The experiment of M. Chauveau proves that the* (illegible)][8]

NOTES

[1] Eakins's text is extensively quoted and paraphrased in Lloyd Goodrich, *Thomas Eakins* (Cambridge: Harvard University Press for the National Gallery of Art, 1982), vol. 2, pp. 128–30.

[2] See Kathleen A. Foster, *Thomas Eakins Rediscovered* (New Haven: Yale University Press, 1997), pp. 325–27, cats. 82–87; and Susan Danly and Cheryl Leibold, *Thomas Eakins and the Photograph* (Washington, D.C.: Smithsonian Institution Press for the Pennsylvania Academy of the Fine Arts, 1994), p. 206. Bregler gave a print from one of Eakins's glass negatives in his collection to the Philadelphia Museum of Art (fig. 21). Theodor Siegl, *The Thomas Eakins Collection* (Philadelphia: Philadelphia Museum of Art, 1978), p. 168, dates the photo to 1884. In a footnote to Eakins's paper, the anatomist Dr. Harrison Allen remarks that Eakins showed the members of the Academy of Natural Sciences some photographs "made at the University of Pennsylvania in 1883," perhaps referring to images such as this one. However, the Muybridge project took place in 1884 and 1885, and most of the surviving images in Eakins's series were made in 1885.

[3] This is a close paraphrase of a passage in Chauveau, *Traité d'anatomie*, p. 227. At the end of the paragraph Eakins has written "Cruveilhier," probably a reference to the French pathologist and anatomist Jean Cruveilhier (1791–1874), who authored a series of works on anatomy.

[4] Eakins most likely refers here to the French neurologist Guillame Benjamin Amand Duchenne de Boulogne (1806–1875), an early pioneer of electrophysiology (the study of neuromuscular stimulation using electricity).

[5] The French physiologist Etienne-Jules Marey (1830–1904) made extensive use of cinematography to study animal locomotion. Eakins used a Marey camera for his own locomotion studies; see "Notes on the Construction of a Camera," pp. 101–8 above.

[6] Eakins started a new paragraph with these words but did not complete the thought.

[7] Eakins wrote the words "Chauveau experiment" above this sentence in the manuscript.

[8] The manuscript ends with this crossed-out text.

Refraction

Eakins's thirty-six-page manuscript titled "Refraction" seems to be a self-contained text, only tangentially related to the drawing manual or to his notes on the construction of a camera (see Appendix I). In the drawing manual, he addresses the topic of refraction briefly in his chapter on reflections, noting the practical use to artists of the "law" governing the bending of light as it passes through water. This text, in contrast, has the measured strategy and careful, detailed documentation of the mathematician and camera-maker (fig. 22). Much like his notes on equine anatomy (see Appendix II), it records independent personal research to be shared with an audience of professionals and intellectuals, not a class of art students. Cleanly written, and so probably copied from a more informal draft, the text is a sequence of propositions and equations representing Eakins's attempts to correct the natural distortion of light passing through a camera lens, a challenge that perplexed many amateur and professional photographers interested in perfecting the technology. Like many others, he proposed adding a second, corrective lens to redirect the rays before they hit the photographic plate.

The physicist Joel Henkel, then at Youngstown State University in Ohio, reviewed Eakins's manuscripts in 1972 and offered to reconstruct the missing illustrations based on the text. At that time, he noted the distinctiveness of the text on refraction, which basically amounts to "a short course on geometrical optics." Henkel observed that Eakins's lens formulae were developed from Snell's law of refraction, and noted that "these formulae include the lensmaker's equation, thin lens approximations, thick lens corrections, and spherical aberration expressions. He treats prisms, planoconvex, double convex, meniscus and even elliptical lenses, using the method of tracing a thin pencil beam through the optical system. Eakins' mathematics includes use of derivatives to find extrema and series expansions to estimate the order of corrections. The treatment is typical of that for a thorough course in geometrical optics."[1]

An earlier section of Eakins's text, now lost, may have introduced his "course"

and given his initial propositions. In the extant manuscript, the propositions begin with IX (finishing with XXXI); the formulae, numbered for internal reference, begin with 17 and conclude with 97; and a section numbering system begins on page 3 with the number 45 in parentheses and ends with 110. The text is scattered with nine small diagrams, although only the last one (on page 35) is labeled, "fig. N," suggesting fourteen in total. Page 25 has a large section torn out of its lower left corner. Given the arcane and fragmentary character of the text, only a synopsis of the contents is given below, to suggest the principal topics. The manuscript itself is available for study in the Eakins Archive at the Philadelphia Museum of Art.

The text begins with Eakins's statement of the Law of Refraction ("The sine of the angle of refraction bears a constant ratio for a given medium to the sine of the angle of incidence"), expressed in mathematical terms that represent the passage of a ray of light from a denser to a rarer medium. He describes the interdependent relationship of reflection, refraction, and the angle of incidence. He then asserts the first of a series of propositions, each of which is followed by illustrative diagrams or equations (omitted here).

Proposition IX. To determine the course of a simple ray, or of a small pencil of rays, refracted by a prism

Proposition X. To find the deviation of a ray, or of a small pencil of rays, incident perpendicularly on one of the surfaces of a prism

Proposition XI. To determine the deviation of a ray, or of a small pencil of rays, when the angles of incidence and emergence are equal

Proposition XII. The angles of incidence & emergence of a ray passing through a prism are equal when the deviation is a minimum

Refraction by Lenses

Proposition XIII. To determine the course of an indefinitely small pencil of rays, passing from a rarer to a denser medium, through a spherical surface

Proposition XIV. To determine the course of a small pencil of rays falling on a lens; the radiant point of the pencil being in the axis of a lens

Proposition XV. To determine the form of a small pencil refracted by a medium, bounded by parallel planes

Proposition XVI. To determine the form of a small pencil of rays refracted by a double convex lens

Proposition XVII. To show the method of applying, to the approximate focal length found for a double convex lens, a corrective for the effect of thickness

Proposition XVIII. To find the focal length of a sphere for parallel rays

5.

δ, is to be made equal to zero, whence,

$$\frac{\cos\phi.\cos\phi'}{\cos\phi'.\cos\phi} = 1 \quad ... \quad (25)$$

an equation which is satisfied if $\phi = \psi$, or the angles of incidence and emergence are equal.

Refraction by lenses.

50. Prop XIII. To determine the course of an indefinitely small pencil of rays, passing from a rarer to a denser medium, through a spherical surface.

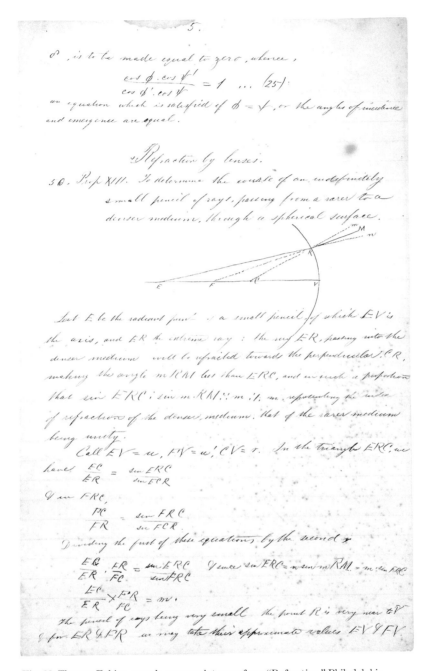

Let E be the radiant point of a small pencil of which EV is the axis, and ER the extreme ray: the ray ER, passing into the denser medium will be refracted towards the perpendicular CR, making the angle mRM less than ERC, and in such a proportion that sin ERC : sin mRM :: m : 1, m representing the index of refraction of the denser medium, that of the rarer medium being unity.

Call $EV = u$, $FV = u'$, $CV = r$. In the triangle ERC, we have $\frac{EC}{ER} = \frac{\sin ERC}{\sin ECR}$

& in FRC,

$\frac{FC}{FR} = \frac{\sin FRC}{\sin FCR}$.

Dividing the first of these equations by the second

$\frac{EC}{ER} \cdot \frac{FR}{FC} = \frac{\sin ERC}{\sin FRC}$ Hence $\sin ERC = m \sin mRM = m \sin FRC$

$\frac{EC}{ER} \times \frac{FR}{FC} = m$.

The pencil of rays being very small the point R is very near to V & for ER & FR we may take their approximate values EV & FV.

Proposition XIX. To determine the form of a small pencil after refraction by a plano-convex lens

Proposition XX. To determine the form of a small pencil after refraction by a double concave lens

Proposition XXI. To determine the form of a small pencil of rays, after refraction by a plano-concave lens

Proposition XXII. To determine the form of a small pencil of light after refraction by a meniscus [crescent-shaped lens]

Proposition XXIII. All the rays which suffer no deviation by refraction by a lens pass through a single point

Proposition XXIV. The object of which the image by a convex lens is required is a plane perpendicular to the axis of the lens

[Propositions XXV and XXVI are missing; lower left corner of the page is torn out]

Spherical Aberration of Lenses

Proposition XXVII. To determine the aberration produced by a single surface

Proposition XXVIII. To determine the aberration in a pencil of rays after refraction by a spherical lens

Proposition XXIX. The incident rays being parallel, to determine the aberration of the pencil after refraction by a spherical lens

Proposition XXX. To determine the ratio of the radii of the surfaces of a double convex lens, which shall produce the least aberration, with a given focal length & aperture

Proposition XXXI. To determine the curvature of the surface of a medium, so that rays passing into it, from a rarer medium, may be refracted to a point

[The text ends with Eakins's concluding assertion:]

If then we form a lens with the first surface plane and the second that of a hyperboloid of which the eccentricity is to the semi-transverse as the index of refraction of the material of the lens is to unity, parallel rays incident perpendicularly upon the first surface of the lens will be refracted to the farther focus of the hyperboloid which forms the second surface.

NOTE

[1] Henkel to George Marcus, April 4, 1972, Eakins Archive, Department of American Art, Philadelphia Museum of Art.

Selected Bibliography

Albright, Adam Emory, as told to Evelyn Marie Stuart. "Memories of Thomas Eakins." *Harper's Bazaar*, no. 2828 (August 1947), pp. 138–39, 184.

Bregler, Charles. "Thomas Eakins as a Teacher." Pts. 1 and 2. *The Arts* 17, no. 6 (March 1931), pp. 379–86; 18, no. 1 (October 1931), pp. 29–42.

Brownell, William C. "The Art Schools of Philadelphia." *Scribner's Monthly* 18, no. 5 (September 1879), pp. 737–50.

Chamberlin-Hellmann, Maria. "Thomas Eakins as a Teacher." Ph.D. dissertation, Columbia University, 1981.

Chapman, John Gadsby. *The American Drawing-Book*. New York: J. S. Redfield, 1858.

Cornu, A. *A Course of Linear Drawing, Applied to the Drawing of Machinery*. Translated by Alexander D. Bache. Philadelphia: A. S. Barnes, 1840.

Danly, Susan, and Cheryl Leibold. *Thomas Eakins and the Photograph*. Washington, D.C.: Smithsonian Institution Press for the Pennsylvania Academy of the Fine Arts, 1994.

Davis, Elliott Bostwick. "Fitz Hugh Lane and John Gadsby Chapman's *American Drawing Book*." *Antiques* 144, no. 5 (November 1993), pp. 700–707.

Foster, Kathleen A. *Thomas Eakins Rediscovered: Charles Bregler's Thomas Eakins Collection at the Pennsylvania Academy of the Fine Arts*. New Haven: Yale University Press, 1997.

Foster, Kathleen A., and Cheryl Leibold. *Writing about Eakins: The Manuscripts in Charles Bregler's Thomas Eakins Collection*. Philadelphia: University of Pennsylvania Press for the Pennsylvania Academy of the Fine Arts, 1989.

Goodrich, Lloyd. *Thomas Eakins*. 2 vols. Ailsa Mellon Bruce Studies in American Art, no. 2. Cambridge: Harvard University Press for the National Gallery of Art, 1982.

———. *Thomas Eakins: His Life and Work*. New York: Whitney Museum of American Art, 1933.

Harding, James Duffield. *Lessons on Art*. 5th ed. London: W. Kent and Co., n.d.

Johns, Elizabeth. "Drawing Education at Central High School and Its Impact on Thomas Eakins." *Winterthur Portfolio* 15, no. 2 (Summer 1980), pp. 139–49.

———. "Thomas Eakins and Pure Art Education." *Archives of American Art Journal* 23, no. 3 (1983), pp. 2–5.

Kemp, Martin. *The Science of Art: Optical Themes in Western Art from Brunelleschi to Seurat*. New Haven: Yale University Press, 1990.

Lippincott, Louise. "Thomas Eakins and the Academy." In *In This Academy: The Pennsylvania Academy of the Fine Arts, 1805–1976*, pp. 152–87. Philadelphia: Pennsylvania Academy of the Fine Arts, 1976.

Marcussen, Marianne. "L'évolution de la perspective linéaire au XIXe siècle en France." *Hafnia: Copenhagen Papers in the History of Art* 7 (1980), pp. 51–73.

———. "Perspective, science et sens. L'art, la loi, et l'ordre." *Hafnia: Copenhagen Papers in the History of Art* 9 (1983), pp. 66–88.

Marzio, Peter. *The Art Crusade: An Analysis of American Drawing Manuals, 1820–1860*. Smithsonian Studies in History and Technology, no. 34. Washington, D.C.: Smithsonian Institution Press, 1976.

McHenry, Margaret. *Thomas Eakins, Who Painted*. Oreland, Pa.: privately printed, 1946.

Miller, Leslie W. *The Essentials of Perspective*. New York: Scribner's, 1887.

Peale, Rembrandt. *Graphics: A Manual of Drawing and Writing*. New York: J. P. Peaslee, 1835.

Rosenzweig, Phyllis D. *The Thomas Eakins Collection of the Hirshhorn Museum and Sculpture Garden*. Washington, D.C.: Smithsonian Institution Press, 1977.

Sellin, David. "Eakins and the Macdowells and the Academy." In *Thomas Eakins, Susan Macdowell Eakins, Elizabeth Macdowell Kenton*, pp. 13–45. Roanoke, Va.: Progress Press for the North Cross School Living Gallery, 1977.

Sewell, Darrel, ed. *Thomas Eakins*. Philadelphia: Philadelphia Museum of Art, 2001.

Siegl, Theodor. *The Thomas Eakins Collection*. Philadelphia: Philadelphia Museum of Art, 1978.

Sloan, Kim. *"A Noble Art": Amateur Artists and Drawing Masters, c. 1600–1800*. London: The Trustees of the British Museum, 2000.

Sutter, David. *Nouvelle théorie simplifieé de la perspective*. Paris: Jules Tardieu, 1859.

Uselding, Paul. "Measuring Techniques and Manufacturing Practice." In *Yankee Enterprise: The Rise of the American System of Manufactures*, edited by Otto Mayr and Robert C. Post, pp. 103–25. Washington, D.C.: Smithsonian Institution Press, 1981.

Valenciennes, Pierre-Henri. *Eléments de perspective pratique à l'usage des artistes*. Paris, 1800. Reprint, Geneva: Minkoff, 1973.

Werbel, Amy B. "Art and Science in the Work of Thomas Eakins: The Case of *Spinning* and *Knitting*." *American Art* 12, no. 3 (Fall 1998), pp. 31–45.

———. " 'For Our Age and Country': Nineteenth-Century Art Education at Central High School." In *Central High School Alumni Exhibition*, pp. 6–12. Philadelphia: Woodmere Art Museum, 2002.

———. "Perspective in the Life and Art of Thomas Eakins." Ph.D. dissertation, Yale University, 1996.

———. "Perspective in Thomas Eakins' Rowing Pictures." In Helen A. Cooper, *Thomas Eakins: The Rowing Pictures*, pp. 78–89. New Haven: Yale University Press, 1996.

Wilmerding, John, ed. *Thomas Eakins and the Heart of American Life*. London: National Portrait Gallery, 1993.

List of Drawings

The illustrations in the drawing manual are reproduced from drawings by Thomas Eakins, all (with the exception of drawing 13) held by the Pennsylvania Academy of the Fine Arts, Philadelphia, in Charles Bregler's Thomas Eakins Collection, acquired with the partial support of the Pew Memorial Trust, the Henry S. McNeil Fund, the John S. Phillips Fund, and the Henry C. Gibson Fund. These drawings have been catalogued and reproduced in their current condition, showing the entire sheet, in Kathleen A. Foster, *Thomas Eakins Rediscovered: Charles Bregler's Thomas Eakins Collection at the Pennsylvania Academy of the Fine Arts* (Philadelphia: Pennsylvania Academy of the Fine Arts; New Haven: Yale University Press, 1997), referenced below as *CBTE*.

Drawing 13 is in the collection of the Hirshhorn Museum and Sculpture Garden, Smithsonian Institution, Washington, D.C., Gift of Joseph H. Hirshhorn, 1996. Full catalogue information and a reproduction of the entire sheet can be found in Phyllis D. Rosenzweig, *The Thomas Eakins Collection of the Hirshhorn Museum and Sculpture Garden* (Washington, D.C.: Smithsonian Institution Press, 1977), cat. 56, p. 116.

Unless otherwise noted, all drawings are pen and black ink over graphite, on cream wove paper. Dimensions are given with height preceding width.

Drawing 1 [The Law of Perspective]
$15^{1}/_{2}$ x $22^{1}/_{4}$ inches (39.4 x 56.5 cm)
1985.68.3.1; *CBTE* cat. 92, p. 332

Drawings 2 and 3 [Diagrams of the Law of Perspective]
$17^{1}/_{16}$ x $22^{1}/_{8}$ inches (43.3 x 56.2 cm)
1985.68.3.6; *CBTE* cat. 95, p. 333

Drawing 4 [The Law of Perspective, Bird's-eye View]
$17^{1}/_{16}$ x $22^{1}/_{8}$ inches (43.3 x 56.2 cm)
1985.68.3.9; *CBTE* cat. 96, p. 333

Drawing 5 [Viewer Position]
16 x $7^{3}/_{16}$ inches (40.6 x 18.3 cm)
1985.68.3.11; *CBTE* cat. 98, p. 334

Drawing 6 [Measuring]
$13^{13}/_{16}$ x $8^{5}/_{8}$ inches (35.1 x 21.9 cm)
1985.68.3.12; *CBTE* cat. 99, p. 334

Drawing 7 [Constructing Space in Perspective]
$16^{3}/_{4}$ x $22^{5}/_{16}$ inches (42.6 x 56.7 cm)
1985.68.3.13; *CBTE* cat. 100, pp. 334–35

Drawing 8 [Inch Scale]
$7^{1}/_{4}$ x $16^{11}/_{16}$ inches (18.4 x 42.4 cm), on buff wove paper
1985.68.3.14; *CBTE* cat. 101, p. 336

Drawing 9 [Plan of a Box]
$11^{13}/_{16}$ x 17 inches (30 x 43.2 cm)
1985.68.3.15; *CBTE* cat. 102, p. 336

Drawing 10 [Plan of Diagonals]
6³/₄ x 17⁷/₈ inches (17.1 x 35.7 cm)
1985.68.3.16; *CBTE* cat. 103, p. 336

*Drawing 11 [Measured Sketch of
Round-top Table]*
10³/₄ x 11¹/₈ inches (27.3 x 28.3 cm), brush and
brown ink over graphite
1985.68.3.17; *CBTE* cat. 105, p. 337

*Drawing 12 [Plan of Tabletop; Section
of Curved Table Leg]*
17 x 14 inches (43.2 x 35.6 cm)
1985.68.3.18; *CBTE* cat. 106, p. 337

Drawing 13 [Perspective of Tilt-top Table]
23³/₄ x 16⁵/₁₆ inches (60.3 x 41.3 cm)
Hirshhorn Museum and Sculpture Garden,
Smithsonian Institution; Rosenzweig,
cat. 56, p. 116

Drawing 14 [Plan of Spiral Staircase]
22⁵/₁₆ x 15⁹/₁₆ inches (56.7 x 39.5 cm)
1985.68.3.24; *CBTE* cat. 109, p. 339

Drawing 15 [Perspective of Spiral Staircase]
22³/₈ x 17¹/₄ inches (56.3 x 43.8 cm), on buff
wove paper
1985.68.3.25; *CBTE* cat. 110, p. 339

*Drawing 16 [Scale for Measuring Small
Parts of an Inch]*
22¹/₈ x 16⁵/₁₆ inches (56.2 x 41.4 cm), pen and
black and brown ink
1985.68.3.27; *CBTE* cat. 113, p. 342

*Drawing 17 [Mechanical Drawing:
Coffee Pot]*
11³/₈ x 14 inches (28.9 x 35.6 cm)
1985.68.3.28; *CBTE* cat. 114, p. 342

*Drawing 18 [Mechanical Drawing: Coffee
Pot (French System)]*
17 x 14 inches (28.9 x 35.6 cm), on foolscap
1985.68.3.29; *CBTE* cat. 115, p. 343

*Drawings 19 and 20 [Mechanical Drawing:
Hoop]*
17 x 14 inches (43.2 x 35.6 cm)
1985.68.3.30; *CBTE* cat. 116, p. 343

Drawing 21 [Perspective Study: Hoop]
14 x 17 inches (35.6 x 43.2 cm)
1985.68.3.31; *CBTE* cat. 117, p. 343

*Drawing 22 [Perspective Study:
Falling Hoop]*
10¹/₂ x 14¹/₁₆ inches (26.7 x 35.7 cm)
1985.68.3.35; *CBTE* cat. 121, p. 345

*Drawing 23 [Perspective versus
Mechanical Drawing]*
5³/₄ x 14 inches (14.6 x 35.6 cm)
1985.68.3.36; *CBTE* cat. 122, p. 345

*Drawings 24 and 25 [Mechanical Drawing:
Brick Shapes Enclosing Yachts]*
14 x 17¹/₁₆ inches (35.6 x 43.3)
1985.68.3.37; *CBTE* cat. 123, pp. 345–46

*Drawings 26 and 27 [Mechanical Drawing:
Brick Shapes Enclosing Yachts]*
17 x 14 inches (43.2 x 35.6 cm)
1985.68.3.38; *CBTE* cat. 124, p. 346

Drawing b¹ [Isometric Drawing: Cube]
9¹/₁₆ x 26¹/₄ inches (23 x 66.7 cm)
1985.68.3.44; *CBTE* cat. 131, p. 348

*Drawing b² [Isometric Drawing:
Carpenter's Bench]*
16 x 13⁹/₁₆ inches (40.6 x 34.5 cm)
1985.68.3.45; *CBTE* cat. 132, p. 349

*Drawing a¹ [Laws of Reflection,
with Wharf and Tree]*
11³/₈ x 17¹/₈ inches (28.9 x 43.5 cm), pen and
brown ink over graphite
1985.68.3.39; *CBTE* cat. 125, p. 346

Drawing a^2 [Laws of Reflection]
15^{11}/$_{16}$ x 26 inches (39.8 x 66 cm), on buff
wove paper
1985.68.3.4; *CBTE* cat. 126, p. 346

Drawing a^3 [Wave Profiles]
13^7/$_8$ x 16 inches (35.2 x 40.6 cm)
1985.68.3.40; *CBTE* cat. 127, p. 347

Drawing a^4 [Reflections on Moving Water]
14 x 17 inches (35.6 x 43.2 cm)
1985.68.3.41; *CBTE* cat. 128, p. 347

*Drawing a^5 [Refraction: A Ray of Light
Hitting Water]*
11^1/$_4$ x 7^1/$_2$ inches (28.6 x 19.1 cm)
1985.68.3.42; *CBTE* cat. 129, p. 347

*Drawings a^6 and a^7 [Refraction: A Stick
in Water]*
17^1/$_{16}$ x 9^3/$_4$ inches (43.3 x 24.8 cm)
1985.68.3.43; *CBTE* cat. 130, p. 348

Drawing a^8 [Shadows]
14 x 17 inches (35.6 x 43.2 cm)
1985.65.3.47; *CBTE* cat. 140, p. 352

Drawing c^1 [Types of Relief]
16^3/$_8$ x 23^{11}/$_{16}$ inches (41.6 x 60.2 cm), on buff
wove paper
1985.68.3.5; *CBTE* cat. 133, p. 349

*Drawing c^2 [Sculptured Relief:
Establishing Slope]*
7^5/$_8$ x 22^3/$_{16}$ inches (19.4 x 56.3 cm)
1985.68.3.7; *CBTE* cat. 134, p. 350

*Drawing c^3 [Sculptured Relief: Tilt-top
Table Exercise]*
8^7/$_8$ x 22^1/$_8$ inches (22.5 x 56.2 cm)
1985.68.3.8; *CBTE* cat. 135, p. 350

*Drawing c^4 [Perspective Study: Floor of
Relief of Tilt-top Table]*
17^1/$_{16}$ x 22^1/$_8$ inches (43.3 x 56.2 cm)
1985.68.3.19; *CBTE* cat. 136, p. 350

*Drawing c^5 [Side and Front Elevations
of Relief of Tilt-top Table]*
17^1/$_{16}$ x 22^1/$_{16}$ inches (43.3 x 56 cm)
1985.68.3.20; *CBTE* cat. 137, pp. 350–51

*Drawings c^4 or c^5 [Variant Study of
Relief of Tilt-top Table]*
25^1/$_8$ x 18^5/$_8$ inches (63.8 x 47.3 cm), on tan
wove paper
1985.68.3.53; *CBTE* cat. 138, p. 351

Photography Credits

Thomas Eakins's drawing manual illustrations (pp. 48–95) were photographed by Barbara Katus, except for drawing 13 (p. 64), which was photographed by Lee Stalsworth.

All other photographs were supplied by the owners and/or the following: Charles Penniman, fig. 18; Photographic Services, Widener Library, Harvard University, figs. 11, 12, 15; Lynn Rosenthal, figs. 2, 7, 21, 22; Amy Werbel, figs. 8, 9; Graydon Wood, figs. 1, 3, 4, 5. Figs. 13 and 14 copyright © The Metropolitan Museum of Art; all rights reserved.

This book is not a facsimile or reprint. Its design was influenced by other drawing manuals and textbooks produced at the time of Eakins's writing. The text was set in Century and Century Expanded. The display headings were set in Akzidenz Grotesk and Clarendon. The book was printed on 80# Cougar Natural Opaque and Smyth-sewn in a paper-over-board cover.